more than a pretty face

The Essential Handbook for Canadian Models

Follow your dreams!
Heather

Heather E. Young

Feather Books • Vancouver

Copyright © 2003 by Heather E. Young
Copyright © on all photographs reside with the photographers, models and, where applicable, the company that commissioned the photo.
Some images © 2002 - 2003 www.clipart.com

All rights reserved. No part of this publication may be reproduced, stored in a retrieval system or transmitted in any form or by any means, electronic, mechanical, recording or otherwise, without the prior written permission of the copyright owner.

To show your appreciation for the time and effort that the author and publisher have invested in this book, please purchase this book and make it part of your personal library. The investment will be well worth it.

While every effort has been made to trace ownership of all copyrighted material, to secure permission from copyright holders and to ensure the accuracy of the photo credits, the author and publisher invite readers to bring any errors and omissions to their attention so that they can be corrected in future editions of this book.

All inquires should be addressed to:
Feather Books
14878 - 59th Avenue, Surrey, BC, V3S 3W8
www.featherbooks.ca and featherbooks@shaw.ca

National Library of Canada Cataloguing in Publication Data
Young, Heather E., 1975-
 More than a pretty face : the essential handbook for Canadian models / Heather E. Young.

 Includes bibliographical references and index.
 ISBN 0-9731607-0-5

 1. Models (Persons)--Vocational guidance. 2. Models (Persons)--Vocational guidance--Canada. 3. Fashion--Vocational guidance. 4. Beauty, Personal. I. Title.
 HD8039.M77Y68 2003 746.9'2'023 C2003-910242-4

Cover Model: Agnes, Cover Photographer: Laurel Breidon
Back Cover Photographer: Helen Tansey
Layout design by Viera Rafajova.
Printed and bound in Canada by Dollco Printing.

In view of the complex, individual and specific nature of this book's content, this book is not intended to replace professional medical, legal, accounting or other services. The author and publisher expressly disclaim any responsibility for any liability, loss or risk, personal, professional or otherwise, which is incurred as a consequence, directly or indirectly, of the use and application of any of the contents of this book.

I would like to dedicate this book to each model,
past and present, who defies the stereotypes.

The credits for the photos on this page
are found elsewhere in the book.

TABLE OF CONTENTS

Model: Sandra Lavoie

TABLE OF CONTENTS

ACKNOWLEDGEMENTS 8

CHAPTER 1

FOR STARTERS • YOUR PREFACE

INTRODUCTION 11
DEAR PARENTS 14

CHAPTER 2

THE APPETIZERS • YOUR BASIC INFO

TYPES OF MODELS 17
MODELING SCHOOLS 24
CONVENTIONS 25
FINDING AN AGENT 26
INTERVIEW WITH A BOOKER 32
MOTHER AGENTS 34
MODEL'S BIO - ALEX COVENTRY 36

CHAPTER 3

THE HERBS, SPICES & SEASONINGS • YOUR BUSINESS & YOUR TOOLS

GO-SEES & CASTINGS 39
PORTFOLIOS & COMP CARDS 40
CLOTHING 41
YOUR MODEL BAG 42
YOUR AGENT'S TOOLS 44
MODEL'S BIO - CONRAD 48

The credits for the photos in the Table of Contents are found elsewhere in the book.

CHAPTER 4
THE AMBIANCE • YOUR SELF

YOUR INNER AND OUTER BEAUTY 51
GLOWING SKIN CARE 51
GLASSES AND SHAPELY BROWS 53
HEALTHY DENTAL CARE 54
YOUR BEAUTIFUL NAILS 56
HAIR STYLING AND CARE 57
BODY CARE FOR YOUR LIFE 58
MODEL'S BIO - CHANTALE NADEAU 60
A LESSON IN HAIR REMOVAL 62
BUILDING SELF-ESTEEM with a special excerpt from
The Six Pillars Of Self-Esteem by Nathaniel Branden 63
YOUR MAKE-UP 64
Basic make-up 65
Make-up on set 66
MODEL'S BIO - SOPHIE 68

CHAPTER 5
THE MAIN COURSE • YOUR CAREER

TESTING 71
WORKING IN A TEAM 72
PHOTO SHOOTS 73
PAYMENT INFO 73
LOCATION, LOCATION, LOCATION JOBS 74
SMILE, YOU'RE ON CAMERA 75
THE RIGHT FIT - CLOTHES 75
USING PROPS 76
FASHION SHOWS 77
VOUCHERS 78
RELEASES 79

TRAVELING AROUND 81
MODEL'S BIO - CRISTY McNIVEN 84
ACTING 86
ACTRA 87
AUDITIONING 89
WHAT TO WEAR 90
GETTING AHEAD 90
CANADIAN MARKETS 91
Toronto 92
Montreal 92
Vancouver 93
Smaller Markets 93
MODEL'S BIO - KALYANE TEA 94

CHAPTER 6

THE BILL • YOUR ACCOUNTING

INCOME TAX 97
GOODS & SERVICES TAX (GST) 98
BOOKKEEPING FOR SMARTIES 99
MODEL'S BIO - JANINE LONGLEY 104
FINANCIAL PLANNING FOR THE NEXT MILLENNIUM 106

APPENDICES

THE INGREDIENTS • YOUR RESOURCES

APPENDIX 1: ACTOR'S UNIONS 109
APPENDIX 2: TRAVEL INFO 111
APPENDIX 3: GLOSSARY 114
APPENDIX 4: OTHER RESOURCE BOOKS 117

INDEX 120
ABOUT THE AUTHOR 124

ACKNOWLEDGEMENTS

There have been so many supportive people around me without whom this book would have been very difficult to complete - instead it has been fun and challenging!

Thank you to MJ, Manoushka, Carole, Daisy and Ann, who have been mentors, friends and great agents. You are wonderfully strong women with whom I have been honoured to work. Manoush, thanks for your invaluable assistance with this project - you have been an angel. All the models and photographers who have taken part in this book have been most generous with their beautiful images. This book could not have been possible without their photos and enthusiasm - thank you. A very special thanks to the models - Alex, Chantale, Conrad, Cristy, Janine, Kalyane and Sophie, who have given such thoughtful and important contributions in the "Model's Bio" sections.

There are many professionals to whom I am indebted. Thanks to top Canadian runway model, Sophie, for her runway and modeling expertise. Thanks to Lisa Sim, renowned make-up artist and owner of make-up store Flamme in Montreal, for her very practical make-up advice. Thanks to Zohar Bardai, hair stylist extraordinaire at Tonic Salon & Spa in Montreal, for his contributions to the hair-care segment. Thank you Rhonda Croft, the booker at Kamera Kids for teaching me about how modeling for kids is different (and similar!) to modeling for teens and adults. Thanks to Dr. Flanagan for his time and for sharing a wealth of great information on dentistry. Thanks to Sam Heiydt, BPA for her ability to access every government phone number, website and brochure. Thanks to Meghan Whittaker-Van Dusen, LLB for her constant legal counsel. And thanks to John C. Young, CA for his assistance with the financial planning and accounting portions of the book. Thanks to Brandon Hall at Sutherland and Karina Shalaby at SPECS as they gave invaluable assistance helping me find phone numbers and chase down models. I would like to thank everyone at Dollco Printing in Ottawa for being so helpful and supportive. My editor, Fina Scroppo is so very talented and has been most helpful and

encouraging. Thank you, Fina. Finally, my layout designer, Viera Rafajova has been full of great, creative ideas. I appreciate how generous all of these professionals have been with their knowledge, time and enthusiasm.

Of course my parents and friends deserve so much acknowledge that I could not possibly do them justice in a few sentences. Thanks to my Mom for her tireless proofreading and encouragement on the book and in life. Thanks to my Dad for supporting my career right from the very first day and for all his business and everyday advice. Thanks to my brother, John who, with just one look, reminds me to keep life in perspective. Thanks to Sam, Meg and Sarah for their round-the-clock support. They are the best friends in the whole universe! A big thanks goes to Kent for, not only coming up with the title, but for helping me with the thankless day-to-day activities of putting together a book. There are so many friends and family members who have provided me with support and encouragement. Thank you to my Grandmas, Uncle Bob, Uncle Peter, Aunt Linda, Uncle Paul, Roseanne, Lauren, Matt, Chris, Linds, Rowshan, Olivia and Kate. If there's anyone I've forgotten, I'm sorry and you will only be pressured to buy five copies of the book instead of ten, like the others.

CHAPTER 1

Model: Sophie. Photographer: Laurel Breidon

Chapter 1
For Starters • Your Preface

Introduction

Modeling can offer a unique experience. Besides, how many jobs pay you to see the world?! Luckily for the aspiring model, there's an endless possibility of getting into the field. Perhaps you've always dreamed of spending your summers in Paris? Maybe you're a trained ballet dancer and you'd like to be featured in ads that need your talent? Have you dreamed of being in a fashion show walking down the catwalk? If you wish to get involved in modeling on any level, you should be as prepared as possible for this competitive business. In this book, I'll share many of the lessons I've learned over the last 14 years as an international model so that you too can learn the valuable skills to become a great model. You'll get a peak at the industry from a whole new perspective - I've revealed many of the insights I wish someone had told me about when I was starting out.

My philosophy is simple: I see the modeling industry as a business and I approach it with a practical and professional attitude. There are enough things in life you have to learn the "hard way" so you might as well learn as many as possible "the easy way" - by learning from a very informative book based on practical, real-life experience. By taking you inside the life of a model, I'll give you first-hand information on how to prepare for and make the most of your career. I learned from many helpful and informative people along the way. However, when I was first starting out, I had lots of questions but no source to help me answer - don't let that happen to you. Since I've been involved in the business, young models and parents continuously ask me questions about the business. Even members of my family field queries about the art of being a model! So began the seed for this project, and now I want to share my experience in a book that could reach even more aspiring models.

Models can have many types of fulfilling careers. Many of them do it as a hobby - they work part-time while they pursue other dreams, such as their education or another career. Some do it full-

time, but for a limited period, like a summer, a semester or a year. Then there are others who do it full-time for a few years or for many years. Which will it be for you?

When I began, I knew that there were "supermodels" but I had no idea "non-supermodel" women or men could earn a living being a model. I didn't realize that there were, and continue to be, hundreds of women and men happily supporting themselves as models in Canada. You might be saying, "I've never heard of these models" because they're not household names, yet they have familiar faces and successful careers as models. In fact, several of them are profiled in the chapters ahead.

Different looks, markets and timing allow for different types and lengths of careers. If you hope to follow this dream, you need to maximize your earning potential and manage the direction of your career. The most successful models are the ones who persevere and make their career come to fruition. This book will help you reach your modeling goals. For parents who have concerns about the business, I've included a letter to them in my next section to help them understand that modeling is a viable career option.

Among all the stereotypes about models, the one that I think has the least amount of truth is: Models don't really work and get paid lots of money. If you want to be a successful Canadian model you'll need to create the "right look," have good timing in the market, acquire a knowledgeable agent and work hard and, in some cases, without monetary compensation. For instance, you won't get paid to go on job interviews which are time consuming - in Europe you can have up to eight in a day! However, once you create a professional network and demonstrate your professional abilities, the financial rewards and travel experiences can be good, and often great. Like in any business, you'll have to make an investment in time and money. But, this is a worthwhile investment, unlike your last boyfriend!

As you'll discover, there's no bigger truth to my big premise in this book: "Be Prepared To Be Professional." I don't just mean remembering to say your "please" and "thank-yous," but that you are conscientious in your career by always presenting your most professional

self - I'll give you the scoop on being a professional model in the following chapters. Trust me, if you apply this motto to what you do, it won't go to waste. It's applicable to all occupational pursuits and dovetails to the life philosophy of being the best you can in everything you do.[1]

Quick Model Tip:
Look for these boxes throughout the book for practical, and sometimes unusual, tips.

MODELS' BIOS: You'll meet seven models that have contributed to the success and reputation of the Canadian modeling industry. Look out for their biographies throughout the book. These models are more than pretty faces!

[1] I will refer to model, agent, photographer and others as "she" even though the information pertains in the same way to men, except in instances where I have noted otherwise.

> Modeling can be a viable and rewarding career. "But, what about the pitfalls?" you ask. Read on. My letter to parents helps to dispel some modeling myths and my chapters ahead tell aspiring models how to make it happen for themselves.

Dear Parents:

Welcome to the world of modeling! The purpose of my book is to give your daughter or son a background into this dynamic industry. Over the years, I have received many questions from parents about how their teen can get involved in the business and about the risks. This interest from parents is what convinced me to launch this book. For the past year and a half, I have been compiling a resourceful guide to provide aspiring models with specific information on understanding and working in the business. I hope this book helps to answer many of your questions and inspires your teen to delve into a business that has rewarded me with a fulfilling career.

If you bought this book because your daughter or son has expressed an interest in modeling but you're worried about the industry, then let me try to dismiss the myths of modeling and tell you about the realities of the business.

Is my child too young for the business?

Models are starting in the business at younger and younger ages and there may be some opportunities she can get involved in locally. However, any reputable agency won't send a young girl of boy overseas without a guardian if they are under age 17. Many times, your child's maturity level will determine if she's ready for the business since it will play a big role on her success. She'll have to interact with agents and clients, which requires a healthy self-esteem and good social skills.

An agent should always welcome the involvement of a parent. If an agent doesn't accept parents in the business, do NOT deal with them. If you still feel she's too young or not mature enough, then you could help her to learn about the business and satisfy her curiosity in a very safe way - by reading this book and perhaps even taking a modeling course from a reputable school. Then reconsider her interest in the business when the time is right.

What about all bad people and the drugs and alcohol in the business?

There are dishonest and ill-intentioned people in every business. Your daughter has to have the skills to deal with people - be they "good" or "bad." As for the abusive substances, teens can be exposed to drugs and alcohol everywhere, including their own schoolyard. Every teen needs a good foundation from which to grow to be a responsible person. In dealing with specific situations, try practising at home with old-fashioned role-playing. Also, encourage your child to consult you and other adults they trust when situations come up. And, always ensure your child is only working with reputable agencies.

The modeling industry is not as terrible as the press can make it out to be - you'll often hear reports on the "bad" and glorified news. Your daughter or son will have to use the head on her shoulders. Remember - she is more than a pretty face!

There are plenty of trustworthy people in the modeling business and I have worked with some wonderful clients, agents, photographers and many others who have enriched my working life. I hope that I can pass on some of the joys and educational experiences I've had over the years.

Chapter 2
The Appetizers • Your Basic Info

Types of Models

Models usually start their careers in their early to mid-teens, although it's possible to begin at any age, given your market and your dedication. The teenage years (from 15 years old upwards) offer a myriad of opportunities in modeling and provide you with an opportunity to travel without the restrictions from other jobs or commitments.

There are several different types of models. Perhaps you fit into one or several of these descriptions. These categories are meant to give you an outline and aren't necessarily set in stone. Keep in mind that all models should have a well-proportioned body, a pretty face and good skin. Here are the most common types of models:

BEAUTY MODELING

A beauty model has beautiful facial features, perfect skin, great teeth and smile, a symmetrical face with well-aligned features. "Beautiful" can be difficult to distinguish because there are so many different features that fit into beautiful, from exotic to classic. You may traditionally see this type of model on the cover of magazines or in ads for skin care and make-up. This model is usually not shorter than 5 ft. 7 in. and also works as a catalogue model.

Model: Kalyane

Model: Sandra Lavoie

RUNAWAY MODELING

A runway model is between 5 ft. 9 in. and 6 ft. tall. With training, runway models walk with grace and style. Runway models can work year-round in shows and for print clients, such as magazines and catalogues, but the bulk of their work will be during the "show seasons," which are the times of year when designers hold their shows. See more runway models on page 78.

Model: Sophie, Photographer: Bruno Petrozza, Show: Muse

CATALOGUE MODELING

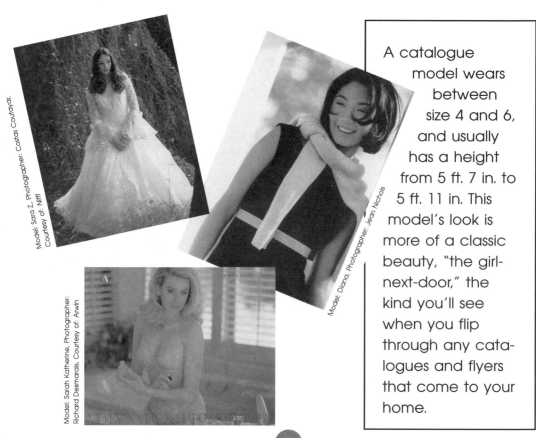

Model: Sara Z, Photographer: Costas Coutayar, Courtesy of: Niffi

Model: Sarah Katherine, Photographer: Richard Desmarais, Courtesy of: Arwin

Model: Diana, Photographer: Jean Nichols

A catalogue model wears between size 4 and 6, and usually has a height from 5 ft. 7 in. to 5 ft. 11 in. This model's look is more of a classic beauty, "the girl-next-door," the kind you'll see when you flip through any catalogues and flyers that come to your home.

EDITORIAL MODELING

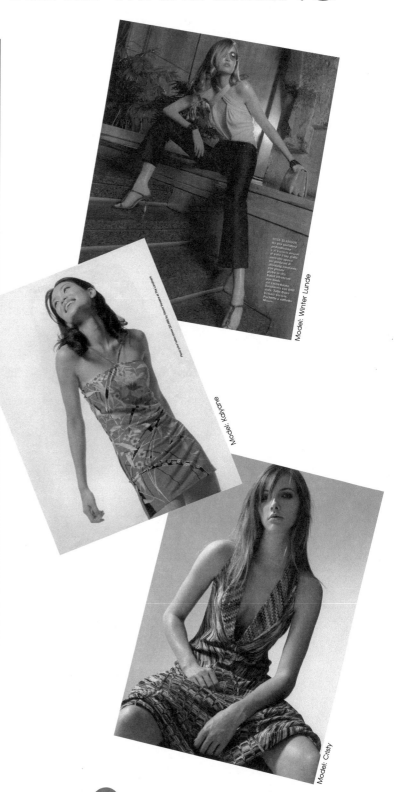

An editorial model has the same physical requirements as a catalogue model, but has a look that you see in fashion magazines. Her look varies depending on what is "in fashion." If an editorial model is tall enough and performs well on the catwalk, she may also qualify as a runway and, possibly, a catalogue model for designers.

MALE MODELING

A male model is between 5 ft. 11 in. and 6 ft. 2 in. and wears a 40 Regular to a 42 Long suit. There are several opportunities for male models in Canada and even more abroad. They work for many editorial, catalogue and runway clients, however, there are no opportunities for petite or plus-size male models. Less markets for male models means fewer jobs and often less pay than their female counterparts. Male models usually start their careers later (in their 20s) but work for longer periods of time, well into their 30s and 40s.

CHILD MODELING

A child model needs to be co-operative and sociable. She must also have a co-operative parent with a flexible schedule. A child model should be able to speak clearly to adults by three years of age. Babies and children's work is usually centred on catalogues, advertisements and family and parenting magazines. The Kamera Kids agency in Toronto describes their kids as: "self-confident, outgoing and personable."

There are some deviations to the physical requirements outlined in these descriptions - every market and every agency has different preferences. For example, Japan (in Tokyo and Osaka) has a very large and lucrative modeling market and clients prefer models who are between 5 ft. 6 in. and 5 ft. 9 in. with small figures and busts. If you fall into the margins of any of the physical requirements, you can make up the difference with a substantial portfolio and confident personality.

Quick Model Tip:
The Canadian acting union does not allow the hiring of ies younger than fifteen days old.

Here are the types of models that belong to smaller categories. These models have more specialized "looks" and will have to seek out specialized agencies and larger markets for increased work opportunities.

A parts model has a part of her body that is very well taken care of and especially beautiful. The most common parts for photography are legs and hands (although not necessarily on the same person). A shoe model must wear size 6 medium width shoes and have a medium to high arch. A hand model must have long, slim hands with nice nail beds. A leg model must have long and shapely legs. Feet are photographed for shoes, socks and foot-care products. Hands are used for jewellery and nail product catalogues and advertisements. Legs are shot for hosiery, footwear, shaving products and body lotions. A parts model must be free of scars, tattoos, bruises and scratches.

A petite model is between 5 ft. 5 in. and 5 ft. 7 in. and usually has a wholesome, healthy appearance. She may do some advertisements or part work but most of her work will come from catalogues for stores and designers with petite clothing lines.

A plus-size model is 5 ft. 8 in. to 5 ft. 11 in. and she wears a size 12 to 18 depending on her height. She must have equal face and body proportions with great facial bone structure. She has a current look, but it isn't too trendy because plus models do a variety of work from swimwear and lingerie to sportswear and formal wear in magazines, catalogues and advertisements. Generally, plus-size models are over 20 years old, as most of their jobs will be shooting women's wear and not teen fashions.

An elegant model is over 35 years old and she'll work mostly for catalogues, but she'll also do magazines, runway shows and advertisements.

A fitness model is an athlete or a person with a very fit physique. Her height is not as important as it is for other types of modeling. She'll find work in film, television, commercials and print ads as well as in fitness, health and bodybuilding magazines.

Often models fit into more than one of these categories. For example, Kalyane does great work as a beauty model and an editorial model.

Also, consider the beautiful Katie, for instance, who works in Toronto for many catalogue companies, such as Sears, The Bay and Amway, and also has magazine clients in Montreal like *Ocean Drive* and *Clin d'Oeil*! She is fortunate to have a flexible look that, depending on her hair, make-up, clothing and lighting, fits commercial, catalogue or trendy, editorial work. Naturally, the more of these roles you can play, the more work will be available to you.

While agencies and clients demand strict physical requirements in the modeling industry, there's one important feature that can give you an edge - your personality. Fiona Harold, author of *Be Your Own Life Coach*, explains that, "In the world we live in, making the most of your personality is absolutely crucial because it is the one thing that can really get you ahead." No matter what your look or your profession, having an agreeable personality is always an asset. Nobody wants to work with Cruella De Vil! Even if it's just your pinkie finger being used in a shoot, you should be on your best behaviour. Your personality and professionalism are even more important to clients when you're working with the same team of people while you're away photographing on location. Canadian male supermodel, Rainer Andreesen explains that, "To have a good attitude in this business, where you're a pleasure to work with, you're going to get another job from these same people because they enjoy being with you. If you have an attitude problem, where you're 'it' and 'it's all about me,' you're not going to get another job."

Whatever "type" of model you are, whatever "look" you have, you must be prepared to be professional. Read on.

Modeling Schools

Enrolling in a modeling school is absolutely not a necessity for becoming a model. However, modeling school can be an excellent opportunity to learn about the business while gaining practical skills in self-improvement and boosting self-confidence. Karen, a 13-year-old honour roll student was looking for a new hobby. She and her aunt went to a local modeling school in Southern Ontario to speak to the director about different courses. If Karen is able to pursue a modeling career in the future she'll have a head start, since she'll already have learned about runway walking, make-up application and photography posing. Such programs offer other valuable skills - when Karen enters the business world, for example, she will have already learned about interview, communication and personal presentation skills, including how to dress for a specific situation. Whatever path she pursues in life, this training provides a base on which to build, which exemplifies what Ann Sutherland, owner of Sutherland Models in Toronto, is referring to when she says that modeling schools "provide a foundation for life."

You've probably heard about some of the modeling schools that have received a bad rap over the years for making false promises of work. Credible modeling schools offer potential models accurate and valuable information, as well as quality lessons in developing essential skills. Beware of the schools that make false promises, give out useless information and act as a vehicle for selling other products. While a school or an agency might predict the opportunities for work, it should never promise work to anyone.

There's no doubt about it - modeling schools are a big investment but they can be worth it if they teach you skills such as: how to apply your make-up for different occasions, how to be graceful in front of the camera, how to command attention on the runway, how to confidently present yourself to clients, and other topics you can't master from reading a book, not even this one!

Do some homework (sorry!) before signing up for a school. It will pay off in many ways. Here are some possible questions you'll want to ask as you make your pick:

- Is the school a member of the Better Business Bureau or Chamber of Commerce?
- How long has the school been in business?
- Who runs the school?
- What are his/her credentials?
- Can the school provide you comments or testimonials from graduates?
- Can the school provide you with contact information of former students so that you may speak with them?

Conventions

Conventions are a great way to meet agents. If you're brand new to the business, conventions can be a means of getting your foot in the door. They're also an excellent opportunity to start getting your name out if you're already signed up with a small agency, have some professional photographs and a bit of experience in the business. Conventions are usually held over one to three days at a convention centre or auditorium where there is plenty of space for all the activities. Every convention has a different format but most have a runway show, photo display and talent demonstration. During each of these segments you will have the chance to strut your stuff to potential agents. What are the most important things to remember when at a convention?

- Relax! Enjoy yourself! Be confident!
- Wear a simple outfit with minimal hair and make-up! The agents didn't come to see your keen fashion sense, wild hair-do or ab-fab make-up job.

After the agents have seen all the contestants they will create a list of models and actors they wish to meet. This is called a "call back." At this time those models and actors on the call back lists will line up to see each agent that has requested them. Many conventions also have a time for "open call," which is an opportunity for the participants to go and meet any agents they wish to see but didn't get invited to a call back. This time is a very busy one at most conventions. Because of time constraints, the models and actors will only get to line up and meet a few agents. Do not spend this time meet-

ing those who have given you a call back - you will be able to meet them later during the call back time. Make an educated decision about which agents you should target during the open call.
Here's how:
(1) See an agent that is located close to where live.
(2) See an agent that is from a market that may be prosperous for you.
(3) See an agent that is from a city you've always wanted to visit.

Make the most of your open call time to make as many contacts as possible. **Here's how:**
(1) Have your questions ready, e.g. "What can I do to be at the point where I can work in your market?"
(2) Have colour copies or a card to leave with each agent (see the chapter on "Model's Tools" on page 40).
(3) Take their business card to follow-up.

Conventions can be a pricey investment. But, aspiring models can get their money's worth when they expose themselves to agents from around the world in one weekend. Think of it as investing your time to attend seminars, learn about different markets and meet agents you would not have met otherwise; all in just two days. Some conventions offer panel discussions with experts in the field - another opportunity to meet industry people and learn about the business. Find out which markets are best suited to you. It's less expensive to go to a convention for two days than to travel all over the world to meet agents, who may or may not be able to market your look. The fees for conventions vary from several hundred to several thousand dollars. To minimize attendance costs, choose conventions closer to home so that you won't have huge bills for transportation and accommodation. Remember: conventions aren't the only way to meet agents; read on for more info on finding the right agent for you.

Finding an Agent

The first thing you need to get started in the biz is a trustworthy agent. Your search will vary, depending on where you live. If you live in a small town, there may not be any agencies so you'll have to target nearby cities. If you live in a large city you'll have plenty of options.

Before your appointment to see an agent, ask a friend or a parent to take photos of you. Don't worry - they're not expected to be professional photos but simple snapshots. You'll need a full-length shot in a bathing suit and a close-up shot of your face to show agents. Agents are looking for the basics - your skin and your proportions.

Larger, urban agencies will often have "open calls," a time designated every week when aspiring models can present their photos to agents. Open calls

Amélie's snapshots are good models (excuse the pun). They're simple and pretty - she's the only person in the photo, she's wearing little make-up, her hair is natural and she's wearing a plain bathing suit.

Model: Amélie B.

are also an opportunity to meet a "booker," get feedback on photos and possibly sign up with that agency. A booker arranges the "bookings," which are client's jobs for models. A booker also arranges your schedule and negotiates your rates and conditions. Take the opportunity during the open call to ask the booker your questions about costs and their market.

After reading this book you'll have a good idea about the right look and attitude when meeting a booker, but here a few basic dos and don'ts:
- Do smile and be friendly.
- Don't over-style your hair.
- Do wear very light make-up.
- Don't chew gum.
- Do turn off your cell phone.
- Don't bring your boyfriend.
- Do ask questions.
- Don't be afraid to bring a parent.

When you're choosing a legitimate agency, consider the following:
- Credible agencies do NOT advertise in the classifieds.
- Credible agencies are listed in the yellow pages and may have an advertisement on those pages.
- Credible agencies will not charge you a fee for representation; however, you will incur some legitimate costs, such as photos, business cards and portfolios (see a more complete list on page 46).
- Credible agencies will not guarantee any work but may offer an opinion about available work based on their knowledge of the market.
- Credible agencies will invite questions: How long has the agency been in business? What is the background of the owner? Look at the photos of the models they are representing. Are the phones ringing while you're there? (A sure sign of a busy agency.) Is the booker you're dealing with respectful and professional with you?

If you can't make it to an open call, you can mail in your photos with a letter detailing your age, height, weight, measurements and clothing size. There are three important measurements (in inches) you need to include to give the agency an indication of your size and proportions. The first measurement is your bust and must be taken around the largest area of the bosom. The second number represents the waist and is measured around the smallest part. The final dimension is for the hips and buttocks and must be taken around the widest area. Men's measurements include suit and shirt (collar), waist and inseam sizes. The suit, shirt and inseam measurements will all come from the clothing you're wearing, look in the label to know your size. The waist, like the women's, is taken around the smallest part of your waist. Both women and men should also include in your letter whether you're in school or work, as well as your availability for modeling jobs.

If you're submitting a photo for your child, send a two or three recent snap shots, the child's clothing size, shoe size, a list of activities she enjoys as well as your schedule availability for this new career.

If you're just starting out, you may not get your pick of agencies, but you'll still want to determine if an agency wishing to represent you is reliable, honest and professional. If an agency offers to represent you and you're confident about them, find out:

- What is its commission? The current industry standard in Canada right now is 20%.
- What are your initial costs? Again, you should NEVER pay a fee for representation, but you'll be expected to pick up agency-related costs.
- Will the agency make arrangements for test shoots that will provide you with photos for your book? If not, how will this be arranged? Will the agency supply you with contact information to make the appropriate arrangements?
- How will it market you? What is your "look"?
- Where does the agency believe will be your best location(s) to work (where you live, abroad, in another Canadian city)?
- Does it have connections with foreign agents and scouts?
- How will it be able to work with your current work and/or school schedule?

Quick Model Tip:
When Kamera Kids booker, Rhonda Croft interviews potential child models over the age of three years, she interviews them separately from their parents to find out if "the kids are personable and can talk to me. If they can't talk to me, they won't be comfortable around the client in a big studio with lights and a camera and lots of people." She always asks the kids: "Do you know why you're here?" to get a feeling of what's going on from their perspective.

Finding the right agent requires patience and determination. For one, it takes time to build your presentation - the better the photos in your portfolio, the easier it'll be to join a quality agency in any city. Often you'll have to get some experience before you'll be invited to join a big agency. Just the same, Sandra Lavoie, a successful Canadian model, believes that "it doesn't matter how big your agent is, as long as they're reputable and they believe in you and promote you with enthusiasm." If you're from a small town or city, it's a good idea to join a local agency first, for two reasons. First, the agent may be able to find you local work so that you can get some experience. Second, small agencies outside major cities often have relationships with large agencies in the cities. A scout from a large agency may come to your small town agency once or twice a year looking for a new model like you!

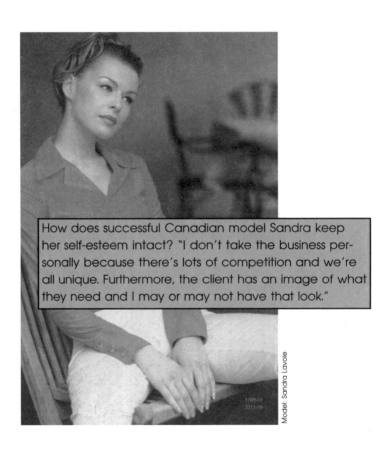

How does successful Canadian model Sandra keep her self-esteem intact? "I don't take the business personally because there's lots of competition and we're all unique. Furthermore, the client has an image of what they need and I may or may not have that look."

Interview With A Booker

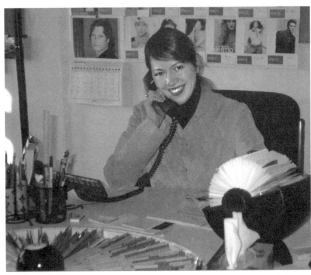

Manoushka Ross is busy on the phone with the booking table in front (where all the jobs are confirmed) and model's cards behind her. Look at that huge Rolodex full of important numbers!

Manoushka Ross has been a booker for eight years with SPECS Model Management/Agence de mannequins SPECS, a well-known and respected agency in Montreal. Ross' responsibilities include: scouting new talent, booking jobs, arranging models' schedules, negotiating with clients and placing models in foreign markets while managing their careers. At conventions and during open calls, Ross answers prospective models' questions about the modeling business.

Here's your chance to listen in on an interview with a booker:

Q: *Where do you find most of your models?*
A: We scout mostly from agencies and schools in small Canadian markets from Victoria to St. John's.

Q: *What do you look for in a model?*
A: There are minimum physical requirements. For example, women must be a minimum of 5 ft. 8 in.; men must be at least 6 ft. tall and they must be good-looking and well proportioned. However, a model must have "a look" that appeals to me. Each booker has his or her own taste, but we're all are trying to find that special quality that appeals to each of us.

Q: *What advice do you have for new models?*
A: Do not have any expectations. Take every job as a gift and then you will enjoy the work you do.

Q: *Should young girls finish school or jump into the business?*
A: You must finish high school and do not trust an agent who tells you otherwise. While you're in high school you can work in the summers until you've graduated.

Q: *Which market is the best for starting a career?*
A: While you're still in school, it's best to work in the market closest to where you live just to gain experience and have fun. When you're ready to travel, Asia is a great market because they pre-pay for your travel and living expenses and it's relatively safe for young girls. Many agencies in Asia will help make arrangements for a parent to come when the model is under 18 years old. Most agencies there also provide transportation to and from all your castings and jobs. Those markets are very clean and used to representing young models.

Mother Agents

Your "mother agent" is usually the agent who first "discovered" you or the agency you've been affiliated with the longest. It's your mother agent who will often help you manage your career and be your liaise with other agencies if needed.

If your mother agent is located in a small city, like Kelowna, Saskatoon, Winnipeg or Halifax, where most of them exist, it'll often send you to other agents in larger centres. If you live in a bigger city, your mother agent will help you find work in their city and abroad. If you leave your mother agent at any point, you should designate another agency with that title by asking them to take over in that respect. For supplying the new agent with new talent (i.e., you), your mother agent will receive a commission from the new agency. The good news is that this fee doesn't come out of your earnings. However, you should be aware that in most cases, a mother agency gets 10% of your gross earnings. If you have any problems with the new agency you can rely on your mother agency to help resolve the problem. You could work with as many agencies as you want, as long as they operate in different geographical areas. Working with more than one agency in the same city/market is as unethical as freelancing (working directly with a client without your agency).

Montreal-based model, Gracie, learned the hard way. While working in Paris, she decided to switch agencies. Instead of communicating with her mother agency and involve it in the switch, she just showed up at another agency and began working for it. In this case, both the model and mother agency lose because the agency gets cut out of the commission and the model has become responsible for that loss. Here's what should have happened: The model should inform the mother agent that she's disappointed with the old agency. The mother agent will contact other new agencies and send a fax or e-mail to potential agencies to arrange an interview for the model. If a new agency is found, the mother agency gets a commission. It might sound a little bureaucratic but, like mom's role in the household, you must respect your mother agency's role.

If you're having a hard time justifying a commission for your mother agent, consider this: A mother agent works hard to find you an agency abroad and doesn't get paid for these arrangements until you work at they get commission. Of course, a lot of their incentive has to do with running a successful business - the more money you earn (abroad or in their city), the more income they earn. But, when you have problems, for example, with a new foreign agency that has arranged improper conditions or is not paying you, you can count on your mother agent to negotiate on your behalf. If your mother agency isn't getting a commission, it can't protect your interests!

Alex Coventry

Photographer: Jacques Gauthier, Courtesy of: Bikini Village

Photographer: Bruno Petrozza

How long have been in the biz?
Fourteen years.

Where have you worked?
Montreal, Toronto, Boston, Dallas, Miami, New York, Hamburg and Munich.

How did you get started?
I was stopped on the street and asked to participate in the Miss Teen Toronto Pageant. I was the runner-up for the title and won Miss Congeniality. In the same year, I was approached to participate in the Ford Model Search. For that event, I was paged over the loud speaker at Canada's Wonderland (an amusement park just North of Toronto) notifying me that I had been chosen as a final contestant and that I must get to a rehearsal for a show that afternoon. Needless to say, I didn't get to enjoy any of the rides! I quickly learned that plans change minute by minute in this new world. Models are notified a day, even hours before the start of a job. You must be prepared to drop everything, pack up and jump on a plane!

Who are some of your clients?
Nygård, Dominic Bellissimo, The Bay, Sports Experts, JAX, Pears Shampoo, Dove, Kellogg's, Holt Renfrew, Vogue Bra, Warners,

Triumph, Elita, Danier Leather, Aldo, Bioré, Sears and Bikini Village.

Have you done any commercials or film and TV work?
I've done lots of commercials. Be prepared for a long day and a lot of waiting around - bring a book! (When I was in high school and then university it was perfect for studying while on set.)

Do you have any advice for someone starting out in the modeling business?
Buy a new outfit for your interviews. You're going to be sent to see clients, stylists and photographers. You want to feel your best. Make sure that you're comfortable in these new clothes. Your comfort and confidence level will be judged as much as your look. Black is always in fashion but keep your look simple. Wear comfy shoes because you'll probably do a lot of walking from appointment to appointment.

Do you have a particular modeling experience you'd like to share?
I remember coming back from a two-week job shooting bathing suits in Jamaica. It was March and still very cold in Toronto. We had to re-shoot one of the bathing suits once we were back home. There I was on Cherry Beach, Toronto, in below freezing temperatures, digging my feet into the hard, cold sand, smiling and trying to look warm. Nobody could tell the difference between the shots in Jamaica and the one in Toronto when they were mixed into the catalogue. Be prepared to shoot winter clothes in the middle of July and vice versa.

What's the best part about modeling?
There are lots of benefits to this job: traveling, unique experiences, meeting new people, working outdoors, working in exotic locations and being your own boss.

What's the worst part of modeling?
At first it's difficult to deal with rejection. Of course you want to get every job. It's hard not to take the rejection personally because you are being judged on your outer shell. If you're going to make a long-term career to modeling, you can't take the "nos" personally. If you're blonde and don't get a job, convince yourself that they're looking for a brunette.

CHAPTER 3

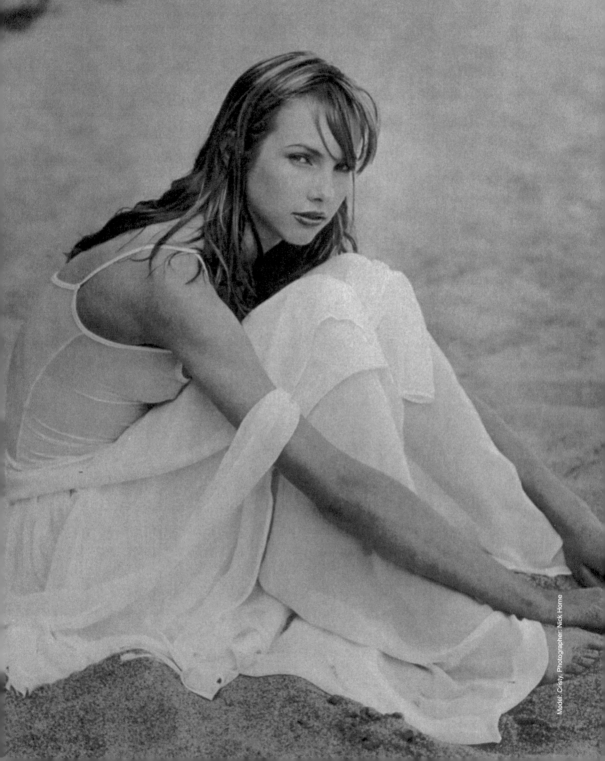

Model: Cristy, Photographer: Nick Horne

Chapter 3
The Herbs, Spices & Seasonings
• Your Business & Your Tools

Go-sees & Castings

Once you've secured an agency, it will arrange meeting with clients. There are two types of meetings - "go-sees" are casual interviews that will be arranged for you to "go" and "see" existing clients, like catalogue studios and photographers. They're an opportunity to get acquainted with some of the agency's regular clients. The second type of interview, a "casting," is an interview held for a specific job. In this case, a client calls the agency with their requirements for the job and asks to see the appropriate models. During a casting you'll meet the client, show your portfolio and leave them a business card.

If the casting is for a fashion show, you'll be asked to "walk" in a designated area or on a ramp. You'll be expected to wear a short skirt to show the client whether you have the physique to model its line of clothing. Your outfit must be fitted and flattering for the same reason, and you'll need to wear high heels to demonstrate your comfort walking with them. Besides, heels are flattering on any legs - creating long smooth calves. As for make-up, keep it fresh and pretty, and your hairstyle well groomed and simple.

> **Quick Model Tip:**
> *Be sure your shoes for a show casting are impeccably clean. They should be a classic style and black. The sole of the heel should be black - a cream or other coloured sole can be distracting.*

Since you'll be meeting potential clients at go-sees and castings, remember the **3 Ps** - be **p**repared, **p**leasant and **p**rofessional. That means have a clean, organized portfolio with extra business cards. Always smile, introduce yourself to the clients and respect other people at castings. Arrive on time, not chewing gum, dressed appropriately and carrying what was requested. Enjoy it!

Winter has an effective card that elegantly and clearly shows her face and body. Her card also reveals her recent success in European magazines.

Portfolios & Comp Cards

You'll need two important sales tools. First, your portfolio (also called your "book") and, second, your business card, known as your "comp card" (also called a "z-card," a "composite card" or just a "card") will travel everywhere with you. Your book is a hard cover album with clear plastic sheets that hold your photos. Your card will probably be designed as a flip card, which is one thin piece of cardboard (about 5 in. by 7 in.) with a headshot on the cover and one to four shots on the back. It'll also include the name of your agency, along with your height, clothing size, shoe size, measurements, hair colour and eye colour.

Quick Model Tip: *When wearing hosiery or trouser socks, wear "toe socks" over your big toes to prevent runs. These can be purchased in the hosiery section of department stores for about $1.*

For babies and kids the promotional tools are a little different (mainly because they grow and change so quickly). Since each market can be different in this respect, ask your agent what she needs from you as a parent. However, usually babies need to have snapshots taken by parents with no one else in the photo. Bring the agent a few to choose from and then she'll have you make copies. For children over three years, they'll need a professional photo taken, enlarged to 8"x10" and copied.

It is your responsibility to make sure you and your agency have plenty of cards on hand. Tell your agency in advance to print cards when the cards are running low. Although these model's tools are expensive, they're necessary. Think of the adage: "You

have to spend money to make money." You're a professional and you're starting your own business. You need to invest in yourself and your career.

Clothing

You like the idea of shopping 'til you drop? Oh, no you don't. Sure, having a complete wardrobe is necessary for your job, but that doesn't mean blowing the budget for every new look in every new colour for every new season. You will, however, need more than your everyday clothes for go-sees and castings. Unless your agency gives you special instructions, you should dress in a fashionable style that is neither too casual, nor too dressy. In many cities, jeans are inappropriate, so double-check with your agency beforehand. If you're just starting out and/or you're on a strict budget, you only need a couple of "casting outfits" that you can mix and match. In all cases, choose stylish, neat clothing that is well fitted to show your figure. Keep it clean and well pressed. The same applies to your shoes and boots - they shouldn't be scuffed, but relatively new looking. Look in magazines and stores for current trends.

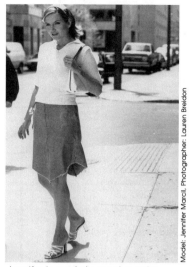

Jennifer is ready to meet a catalogue or commercial client in this great outfit. For magazine clients, she'll wear an outfit that's a bit trendier, such as black, jean-cut pants, a fitted shirt and funky boots.

Besides dressing appropriately when meeting an agency or client, wear only a little make-up and keep hair neat and clean. Never wear perfume - a strong scent can offend some people. Besides, you don't want to leave your signature scent behind on the client's clothing if you're asked to model an outfit during a casting.

Quick Model Tip:
Save on dry cleaning with Dryel, a dry-cleaning product you can use on delicate pieces in your own dryer. Note: use this product with caution. Consumer reports suggest that its fumes are dangerous if used in a poorly ventilated area.

Quick Model Tip:
Carry Shout Wipes (portable stain towelettes) with you in case of a spill on your clothing. You must launder the item ASAP, but, hopefully, you will have prevented the stain from setting.

Quick Model Tip:
If you're called for a bridal, lingerie or swimsuit shoot, bring bra padding. Cotton pads work fine, but silicon "breast enhancers" are the most effective. Silicon pads can vary in price from $50 to $100, so shop around. Note: Surgery is NOT necessary, just bring your own padding!

If you want to add designer pieces but can't afford to splurge, being a model offers another perk: many designers hold sample sales of their clothing about once a season. The sizes are limited but the discounts are very good. Look for notices at your agency or in newspapers advertisements.

If you're fortunate to work for local designers and stores, ask them about buying some of their pieces at a discount from the retail. Don't forget to shop Canadian! Many Canadian designs are more creative than international designers, yet their prices are much less. And, as importantly, you'll be supporting Canadian talent.

Your Model Bag

You'll need to bring this with you to all go-sees and castings. The bag is usually about the size of a large purse or duffel bag. Here's what should be in it for go-sees or casting calls:

- Your day-timer
- Portfolio
- Comps cards
- A small make-up bag
- Nude lingerie
- Nude and black hosiery
- A pair of heels

Men should bring their organizers, portfolios, comps, and make-up powder (in case you're shiny and you're required to take a Polaroid). For both, men and women, of course, you'll also need to bring any special item the agency has requested. For exam-

ple, if the job is for a bathing suit or lingerie catalogue, you'll often have to bring a two-piece bathing suit in which to be photographed. If you show up unprepared, you and your agency will appear unprofessional. It's also in your best interest to bring your own swimsuit; in this case, your style may be more flattering on you than the one that's provided.

For a booking (a job), **women** should bring a larger bag with the following:

- Your day-timer
- Portfolio
- Comps cards
- A voucher book (a small form that you fill out that includes the client's signature to allow your agency to complete the billing - see more information about vouchers on page 78.)
- A nail file
- A hair brush, spray and elastics
- Panty liners and tampons
- Nude lingerie
- Nude and black hosiery
- White and black socks
- Black heels, flats, white sneakers and sandals

For many jobs, you'll also be required to bring specific items, such as white and cream heels for bridal shoots or jeans for catalogue shoots. Being prepared means not forgetting these special requests

Quick Model Tip:
Carry Bioré Cleansing Cloths in your model's bag to quickly remove make-up after a shoot or to clean dirt off your shoe or boot in a squeeze!

Quick Model Tip:
If you're booked for a shot with a husband, wife, baby or even a baby accessory, bring a solid band or ring with you to simulate a wedding band. (It doesn't have to be expensive.) Many department stores want to foster a "family morality" in their image. The stylist will appreciate your preparedness.

Male models should bring the following items to a booking:
- Your day-timer
- Portfolio
- Comps cards
- A voucher book
- A white crew neck T-shirt
- Black and brown belts
- A hair brush and hair gel
- A razor (for some jobs you'll be asked to come with stubble for a rugged look, then asked to shave for a clean look in another shot)
- White and flesh-coloured briefs
- White and black socks
- White sneakers, loafers and black dress shoes

Babies and kids need to bring a model bag to bookings too. Here are some of their necessities:
- A photo to leave with the client
- A voucher book
- Clean, white, simple runners with NO logos
- Light and dark socks
- A white t-shirt
- A hair brush
- Hair gel or spray
- Cover-up for scratches, pimples or pale skin
- Jewellery and hair accessories
- Any special requests made by the client of stylist such as spring shoes, hiking boots or even sunglasses

Your Agency's Tools

Most agencies use a head sheet, a book or a website to showcase their models to clients and foreign agencies. A head sheet resembles a poster with small photos of each model on the agency's roster, whereas an agency book devotes an individual page to each model. And a website, which can be effective in marketing the agency's services, can be organized in many formats. Many agencies require their models to take part in one of these marketing tools - of course; it's to your benefit since agents use them to promote its models.

Models are expected to absorb the cost of this sales tool, which ranges from $75 to $200. Web-based agency tools are becoming increasing used as more clients go on-line themselves. Although preparing material for the Web could be more expensive initially, for example because of scanning costs, you'll save money later on for expenses such as couriers, colour copies and comps.

Another vital marketing tool is a "second book," a colour copy of your portfolio. Your second book will expose you to clients when you're unable to because meet them in person because you're either already working or in school. Many clients also request second books to determine whether certain models are right for a specific job.

Quick Model Tip: *When making laser copies of black and white photos, ask to have them done in colour so copies have richer tones of grey and a sharper contrast.*

To make a second book, simply have your first book, the one you always carry with you, professionally photocopied in colour and then organize copies in a second book. Agencies are also creating electronic second books. In this case, you have to pay to have your photos professionally scanned electronically instead of photocopied.

Agency tools can be your big ticket to that all-important job. Sometimes clients hire models solely based on their second book. Toronto-based model, Alex will testify to that experience! One of the largest jobs Alex has ever done began with a shoot that was booked on the strength of her second book. So, they can be well worth the time and money!

Standard costs for model and agency tools include:

Head sheet/Agency Book/Website	$75-200
Couriers	$1-8 each time
Photo shoots	$150-350 each
Enlargements	$20-40 each
Your portfolio	$40-60
Your second portfolio	$40-60
Colour copies for a second book	$25-45
100 Comps	$100-150
Total	**$700-1400**

No doubt there will be some costs to start your modeling endeavour, whether you make it a career or a hobby. Like any business start-up, it requires investments of money, time, effort and emotional output. Further, in comparison to other small business ventures, this business has a relatively small initial investment required.

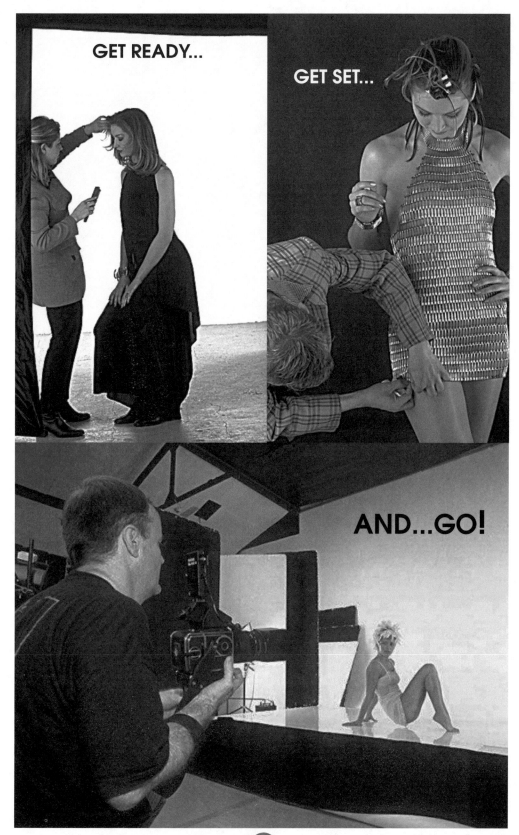

MODEL'S BIO

Conrad

Photographer: Samuel Keaton

How many years have you been in the biz?
Eight years.

Where have you worked?
I've worked in Montreal and Toronto.

How did you get started?
A friend of mine knew that I was interested in modeling. She saw an ad in the *Montreal Gazette* by Mexx Canada. The company was looking for models to try on their clothing and then be photographed to create an in-house catalogue. I was selected along with a couple of other guys. The photographer in charge of the shoot was Maryse Raymond who is a very talented and successful photographer and commercial producer. She thought I had a good "look" for a model. She asked if I would be interested in shooting with her. Of course I accepted, and she took it upon herself to contact a great agency in Montreal on my behalf, and the rest, as they say, is history.

Who are some of your clients?
Clients I've worked with include *Elle Québec*, Boca, Buffalo Jeans, Simon Sebag, Nike Canada, La Senza, Biotherm, Musique Plus, MAC Cosmetics, Guess Jeans, La Griffe D'or, Fashion Cares and most of the men's wear fashion shows and catalogues in Montreal and Toronto.

Have you done any acting?
I recently decided to follow my dream and become an actor after finishing a business degree. To date, I have a small part in an independent film and another small role in a U.S. TV show

under my belt. However, I am looking forward to working on my first feature film.

Do you have any advice for someone starting out in the modeling business?

Having a strong sense of who you are is important in life. It is especially important in this industry. Let's face it, you're being judged on your looks - your appearance, height, size, hair colour, eye colour, sometimes even the colour of your skin. You can't expect to please everyone and you can't let yourself be devastated every time you aren't selected. Yes, rejection is part of the business! I would seriously recommend sitting down and asking yourself why do you want to be a model? And, more importantly, what do you want out of modeling? In my case, it helped pay for my university studies. Presently, it's an additional source of income while I build my acting career. Regardless of the valid reasons you come up with, you'll need a strong, self-imposed sense of realism, hard work and perseverance to succeed in this industry.

As for the marketing behind your business, your portfolio will be key. A good portfolio will open many doors and raise interest in you as a model. All the money that I have spent on my portfolio, I have always made back, and then some. A strong portfolio, along with equally strong comp cards is essential because they are advertising you. The aim is to keep your book fresh and up to date.

What is the best part of modeling?

I enjoy meeting and working with interesting and talented people. In addition, the self-confidence I had to build over the years and the ability to put things in their proper perspective are invaluable assets to me now, in the world of acting.

Do you have any other advice?

Get a good agent! That does not necessarily mean the biggest one out there. Yes, the big ones have pull and they can sometimes get you started pretty fast. But get an agent that truly believes in you. How can they promote you if they don't think you have what it takes? By the same token, you have to back it up with hard work and professionalism on every booking. Good luck!

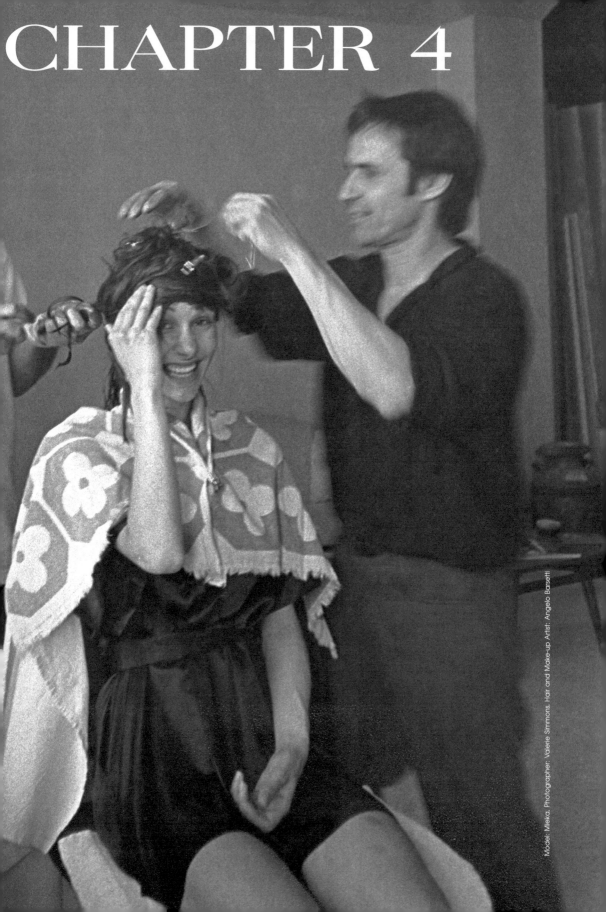

CHAPTER 4

Model: Mieka, Photographer: Valerie Simmons, Hair and Make-up Artist: Angelo Barsetti

Chapter 4
The Ambiance • Your Self

Your Inner and Outer Beauty

To be a successful model you must take care of yourself - your skin, eyes and eyebrows, teeth, nails, hair and body. It's also important to foster a healthy sense of self-esteem and good character. Even good make-up skills are an asset for modeling. These elements of inner and outer beauty are essential and need to be cultivated.

Glowing Skin Care

There are as many skin-care routines as there are colours of nail polish. To find the best one for you, try different products and play with various routines. Here's a sample routine:

(1) Clean your face twice a day even if it's just with water and moisturizer, one of those times. If you're wearing make-up, remove it before going to bed. Start with your eyes - use a soft tissue, cotton pads or cotton balls and Q-tips and eye make-up remover. If you wear waterproof mascara, use a product specially designed to remove it. (Try wearing regular mascara since the waterproof variety is very hard on your lashes.) Gently wipe away mascara and eye make-up.

(2) Then **use a cleanser** and a facecloth to remove your face make-up and sloughed off dead skin simultaneously. After cleansing, pat your face dry and apply toner using a cotton pad or ball. This step removes any impurities that are left behind from cleansing and refreshes your skin. Don't forget to go up to your hairline and as far down as your neck.

> **Quick Model Tip:**
> *If you have large pores with black heads on your nose, try Bioré Pore Perfect Nose Strips or the Ultra Strips. Which one is best for you? They both will get out those ugly black heads but the Ultra are slightly larger in size and include tea tree oil and witch hazel for added effectiveness.*

Quick Model Tip
If you're out of acne cream, use toothpaste instead. Just a small amount on a pimple overnight will do the trick. But don't use toothpaste more than two nights in a row because it's a very powerful drying agent.

Quick Model Tip:
If you're worried about rain, snow or tears on your lashes, try using Estée Lauder's Raincoat. It's a clear layer you apply on top of your mascara to protect the mascara from smudging, as long as you don't rub your lashes.

(3) Apply a mask once a week or exfoliate alternating weeks. Pat your face dry after cleansing and apply as directed. (Never rub - it unnecessarily pulls at your skin. Besides, your skin and hair will get enough abuse on the job!)

(4) Apply a moisturizer that's appropriate for your skin (normal, oily, dry, combination or sensitive). You don't want to over-wash your face and deprive it of its natural oils, but you want to keep it free of dirt. If you deprive your skin of its oils, it will compensate by producing excess oil, which creates blemishes. Make-up artist and storeowner, Lisa Sim, warns: "People in North America have a tendency to over-clean their faces," so beware and just do as much as you need to.

A few notes about moisturizers: If you're not using a moisturizer or a foundation with an SPF, apply sunscreen everyday to protect your skin from the damage of the rays. The sun is your skin's worst enemy! You may also want to use a different moisturizer at night. For example, you may use a moisturizer for sensitive skin in the morning and then a thicker moisturizer for dryer skin to re-hydrate overnight. To increase the effectiveness of your products, change your moisturizer, if not all of your products, every six months or so. You can simply alternate between two products if you like. However, Lisa Sim advises that all products are ineffective if you don't use a mask to clean out blocked skin

every other week and an exfoliator to slough away dead skin every other week. By taking care of your skin now, you're prolonging its longevity for your career and beyond.

Always follow the advice of your dermatologist or beauty therapist for the use and regularity of skin-care treatments. Remember to keep your routine as simple as possible.

Glasses and Shapely Brows

If you wear glasses, you'll be required to be without them for work. Even on go-sees and casting calls, you should meet clients without glasses to give them a better idea of your look. You will need contact lenses or laser eye surgery, which has also become an option for some models. If you have glasses, it's a good idea to bring them with you because they can be a great prop for modeling jobs or acting auditions. If you'd like to experiment with different frames to see which ones suit you best, visit www.eyeglasses.com. When choosing glasses, choose the frames that sit below your brow and match their shape. Most stores offer an anti-reflective coating on lenses, which is useful if you ever want to wear your glasses in front of the camera.

When caring for your eyebrows, you may choose to keep them fuller or thinner, but they must be well maintained. If you're just starting to shape your brows, it's best to go to a professional to have your brows waxed or tweezed. Ask your friends, family or agent to recommend an eyebrow expert in your area. An experienced

Quick Model Tip: *Prevention is the best medicine for wrinkles and skin care. Use eye gel before bed to treat that extra sensitive area. Beware: if you use a facial treatment with vitamin C, avoid mixing it with a product with vitamin K (sometimes found in eye creams).*

If you do have a pair of glasses, it's often nice to have a photo with them in your book so that clients can see that option.

professional will be able to shape your brows to compliment your face.

For great brows, follow these tips:

(1) Work on getting a good shape.

(2) Upkeep, upkeep, upkeep. Once your brows have been shaped, remove new growth a few times a week with tweezers. To prevent over-plucking, don't do too much tweezing in one day. Tweeze for only a few minutes a day and then reexamine your brows the following day.

Healthy Dental Care

Like other features, a model's teeth are very important. Not only do they make a first impression with a client, but also they're one of the first features that are usually noted in a photograph.

Good dental hygiene begins with brushing and flossing regularly. In fact, make it a habit to carry a brush and some floss in case you need them before you rush to a meeting.

If your teeth require extra work to make them more presentable, consider the investment. Plus, the expense can be tax deductible or be covered by insurance! If you need braces, the sooner you get your teeth fixed, the better. In fact, some problems can be solved before the teenage years. Braces come in silver, clear or gold plated. The silver option is the most common and looks great on teens! Many of today's models and "supermodels" started their careers with

Quick Model Tip:
A great treat for your skin is an oxygen facial, offered by some spas. This facial calls for products that are infused with pure oxygen and then a mask that allows live cells in enzymes to "eat" away dirt and dead cells. The procedure will also include a treatment of oxygen steam diffused on your skin to encourage the regeneration of cells.

Quick Model Tip:
Heat rash in the form of pink blotches on your neck and chest can interfere with your work. You can prevent the problem by using a small amount of hydrocortisone cream (0.5%) on the area before applying your make-up.

"railroad tracks," so don't be shy about wearing them. While you have braces your modeling opportunities may be limited since not all clients want to portray that look, but never fear, it's something that is important to do and the sooner you take care of it the better for you and your career.

Once you're in your late teens and beyond, you'll have other cosmetic dentistry options available to you:

Quick Model Tip: *Before plucking your eyebrows, rub an ice cube on the area to numb the skin. Afterwards, apply witch hazel on your skin to sooth the sensitive area and prevent irritation.*

- Reshaping (also called contouring) takes very little time and is an inexpensive procedure. It involves reshaping crooked edges to make teeth appear smooth and nicely shaped.
- Composite veneers (which are created from a hard substance that fills in a small, missing part of a tooth) can make very small corrections to a tooth's appearance, such as a chip in the tooth.
- Bleaching teeth has become a popular procedure and is most effective with custom bleaching trays (like a mouth guard) at home, with whitening strips or whitening gel from the drug store. Laser bleaching at the dentist's office hasn't proven to be as effective.
- When more dramatic changes are necessary, porcelain veneers (very thin plates that go on top of your present teeth) are an alternative to orthodontics. This process can fix crooked teeth, including any Lauren Hutton gaps, and it also covers stains usually caused from smoking and drinking coffee, tea and red wine.
- Gum alterations can make a smile less "gummy." Using a laser, the dentist changes the patient's gum lines. The procedure is done in an hour or two (depending how much work you're having done) in the dentist office. The cost increases with the amount of work needed. Sometimes a gummy smile can be fixed by practising how to smile - practise you smile in the mirror by retraining your muscles to show only your teeth.

If you have any concerns about your smile, dentist Lloyd Flanagan recommends you consult with your dentist to review all your options. Make an appointment to ask all your questions first and then make decisions later. For any procedure, Dr. Flanagan says he considers your bottom lip line, tooth ratios, the balance of the smile, your needs and your desires. If you're not sure how you feel about your smile, "What do you do when you're in front of a camera?" he says. Look at family snapshots (you know the ones around the birthday cake or Christmas tree) - do you always hide your teeth or does your smile brim with enthusiasm?

How you feel about your smile will certainly be portrayed in professional photos, so make sure you feel good about your teeth. Of course, as with any orthodontics or cosmetic dentistry, follow-up care for life is required.

Your Beautiful Nails

Your hands are essential to your physical presentation. In some markets, such as Hamburg, Germany, most clients will examine and judge your hands, whether or not they'll be in the shot. Follow these tips for winning hands:

• Keep nail cuticles pushed backed. Avoid cutting cuticles since they'll only grow back longer.
• Keep hands moisturized and nails evenly filed - not too short but not too long. Ideally, your nails should have a few millimetres of white and be painted with clear or nude polish.
• Don't overlook toes and toenails. Dark or bright nail polish may look great, but if you're shooting open-toed shoes you should stick to nude-coloured toenails, unless the clients requests otherwise. For a good example of well-maintained nails, see the nail polish ads in many women's magazines. Once you spend the time and effort to get your nails in good shape it becomes very easy to keep them well maintained.

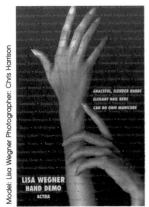

Lisa has done dozens of hand demos for clients such as: Palmolive, Mappins Jewellers, CK One, Kraft and Nokia. Her comp card reveals that she has graceful, slender hands with elegant nail beds.

Hair Styling and Care

Your hair should always be clean and neatly styled for go-sees and castings appointments. A little bit of hair product is okay, but you don't want your hair to look stiff - like the bride of Frankenstein. Clients expect to see a fashionable cut. Ask your agency for input on getting a look that appeals to clients, and browse through magazines for ideas to bring on your next hairstyling appointment.

"It's important to consult with your hairdresser and be realistic about the limitations of your hair," says Montreal hairstylist Zohar Bardai. "Your style's got to be easy to maintain for your lifestyle - how much time do you want to put into your hair every morning? And, most importantly, your hair's got to suit your features."

Agencies often have relationships with local top salons that often offer models discounts (sometimes 30 to 50% off). In any case, keep your hairstyle up to date by making small changes every season or so. However, any time you want to make a major change, you need to consult your agency and consider that you'll have to redo your book and card with photos showing your new hairstyle.

Of course, all the maintenance in the world can't always offset the damage to hair by sun, heat, wind and hot water. To minimize their effects, use a shampoo and conditioner to wash your hair as infrequently as possible. The more you wash your hair the more you'll need to - as soon as you strip your scalp of its natural oils, it begins to produce more. The oil your

Quick Model Tip: *Banish build-up from shampoo and styling products with a white vinegar rinse (keep the expensive stuff for the kitchen!). To make the rinse, mix 4 parts water with 1 part white vinegar. If you're squeamish about using vinegar, switch your brand of shampoo, which is often effective in getting rid of build-up from the last product. Removing build-up helps your hair respond better to products and styling agents.*

scalp produces is like a moisturizer for your hair, so washing your hair everyday is often unnecessary and harsh on your hair.

If you colour your hair, make sure you pamper your scalp with lots of moisturizing treatments, either at home or at the salon, to keep it healthy. Bardai warns that "models should minimize blow drying and shouldn't over-process their hair with colour and perms." Ask your hairstylist about special hair products designed to keep your hair looking great despite harsh elements. For example, use products with SPF in the summer time. If you swim regularly, wear a cap to protect your hair before you jump in the pool. For added protection against pool chemicals, coat your hair in oil (baby oil isn't just for bottoms!) or a cheap hair conditioner before placing a bathing cap.

Quick Model Tip: *If you get uncomplicated acne or even just little bumps on your chest (or anywhere else), use a soap with 2% salicylic acid like Acnex or Fostex on the area.*

The most common damage comes from the hair dryer, so let your hair dry naturally whenever you can. During any modeling job, you'll get plenty of heat from blow dryers, curling irons, hot rollers and flattening irons. If you have long hair, in particular, avoid using a blow dryer altogether because your hair tends to get over-styled on the job.

Quick Model Tip: *Minimize shaving with the lotion Naturally Smooth by Jergens. It claims to help hair grow back finer and at a slower rate - and it works!*

Body Care for Your Life

You can't have a healthy body on the outside without nurturing your inner body. That means living a healthy and balanced life. Simply listed are some of the basic dos and don'ts on maintaining a healthy lifestyle for life, but if you'd like to read more on the topic, there are tons of experts and resources you can find at your local library or bookstore.

Here are the five basics:

(1) Don't smoke or take drugs. Smoking causes damage to your lungs, heart, skin, teeth, gums and you'll smell like an ashtray. Using drugs causes damage to your brain. Period.

(2) Eat a balanced diet full of fruit and vegetables - they're full of vitamins, minerals, and enzymes that are great for your skin and protect you from certain diseases. Don't crash diet but chose to have a healthy, active lifestyle. Drink plenty of water. Limit your caffeine intake.

(3) Exercise regularly. Models bodies need to be well toned but not overly muscular. Consult a Phys. Ed. teacher or personal trainer for a program that suits your body type.

(4) Take care of your skin and practice excellent dental hygiene.

(5) Take time out for yourself every day - even if it's only 10 minutes.

Quick Model Tip:
If you're under the age of 20, avoid using alpha hydroxy acids (AHAs) (unless instructed by your dermatologist or beauty therapist). They peel away the top layer of skin, which can be effective for some people, but damaging to young people's skin. Beta hydroxy acids are not as potent but should still be used with caution. If you use a product containing these acids, limit their use to two to three times a week.

In the short-term, be prepared for casting calls and jobs by shaving or waxing your body hair (facial, leg, underarm and bikini area if you're shooting bathing suits or lingerie). (See the upcoming section on hair removal.) Nothing can be a bigger turnoff than body odour, so be sure to wear antiperspirant or deodorant and brush your teeth regularly. You should also be free of tan lines, which can interfere with a strapless evening gown or a bathing suit photo shoot. To prevent tans lines, keep out of the sun and always wear sunscreen. Besides, the sun's harmful rays can damage skin and hair.

MODEL'S BIO

Chantale Nadeau

Photographer: Bruno Petrozza

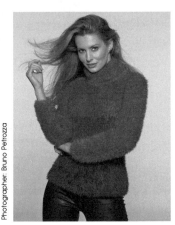
Photographer: Bruno Petrozza

How long have you been in the biz?
Seventeen years.

Where have you worked?
I have worked in Montreal, Toronto, Chicago, Miami, New York, Barcelona, Hamburg, London, Milan, Munich, Paris, Hong Kong, Tokyo and Sydney. I have also traveled to shoot in many exotic locations around the world, such as Broom (Australia), Dominican Republic, Hawaii, New Caledonia, Nice (France), Positano (Italy) and St. Barts, to name a few.

How did you get started?
At the age of 15 I came to Toronto from Rivière du Loup, Quebec, to learn English. I had only planned on staying for the summer but when an agent discovered me I decided to give modeling a try. I haven't stopped yet!

Who are some of your clients?
I have worked for most of the Canadian magazines, including: *Toronto Life Fashion, Flare, Elle Québec* and *Clin d'Oeil*. I have appeared in all the major catalogues in Canada like Sears and The Bay. My most prestigious job was doing the cover of *Marie Claire* magazine in Paris.

Have you done any commercials?
I have done many TV commercials all over the world. My most popular commercial was probably a Pontiac car advertisement where I appeared wearing the actual wedding dress I was married in.

Do you have any advice for someone starting out in the modeling business?

Don't take the rejection or the work too personally. This is a very tough job - you always have to look your best. Take very good care of your mind, body and soul by eating well, exercising, and staying centered with a strong focus on your goals. Do not smoke, drink or take drugs. This behaviour is a sure way to failure and a short career. You must realize that this type of career is very demanding and you must keep your wits about you. Always keep track of your money and save, save, save. You will not always be making the big bucks!

Do have a particular modeling experience you'd like to share?

I have a funny story about my movie debut. It was a Disney movie with the amazing Tony Danza! I grew up watching *Who's the Boss?* and now, I was not only going to meet the man, but work with him. I was so exited! Our scene was simple - we are in a restaurant, I walk up to him and say, "Excuse me, are you Barney Goorman?" How hard could this be? Even though it sounded simple, I practised continuously for a week using every emphasis and intonation possible: "Excuse me, are YOU Barney Goorman?" "Excuse me, are you Barney Goorman!" "'Xcuse me, are you Barney Gooooorman?"

Chantale with Tony after the shoot.

 The big day arrived, and not a moment too soon - I could say my line in my sleep. This should be an easy cut, I thought. The producer explained the scene to me one more time, and away we went. I felt confident. I was a pro. I wouldn't let anyone guess that this was my first shot at fame. I was concentrating to make sure that my voice would come out loud and clear. And it was loud when I blurted out: "Excuse me, are you TONY DANZA?" Tony started to laugh and replied "No Chantale, I'm Barney Goorman." Oops!!!

What's the best part of modeling?

The best part is the travel. You get to live and work in many of the great cities across the world experiencing different cultures and meeting all kinds of interesting people.

A Lesson in Hair Removal

Sorry girls! A model needs to always be conscious of her body hair since it can be caught on film. Waxing isn't always an option for most models because of the time you need to allow for re-growth. If there's a last-minute casting or booking, you'll have to be clean-shaven for the job.

For every shoot, clean-shaven legs and underarms are a must. A hairless bikini line is necessary for lingerie and swimwear castings and bookings. Your agency should always tell you the nature of each job, but if you're not sure, ask your booker.

There's a variety of ways to deal with other unwanted hair growth. Fortunately, laser hair removal may become more of an option in the future if it comes down in price. Upper lip hair may be bleached, waxed or trimmed with scissors. Any unruly nose hair may be trimmed. Dark side burns may be waxed or bleached. Dark arm hair may be bleached. Even very dark eyebrows may be lightened with bleach. These depilatory tools may be useful and even necessary!

Quick Model Tip: *Place rubbing alcohol soon after you shave your bikini line to disinfect the area and prevent red bumps and/or ingrown hairs. To minimize ingrown hair, use a loofah sponge to exfoliate the area.*

Building Self-Esteem

There are many great resources for cultivating your self-esteem and self-confidence, but always remember that self-esteem ultimately comes from within you! Sure, there's a great emphasis on your physical appearance as a model, but you must strive for a healthy self-image.

Here is an exercise that is designed to help us accept our bodies no matter what shape or form. The key is balance - models need o be lean and well proportioned, but not underweight and too skinny. As a young person, your body is changing and will continue to change. Every person, every model has a different body that is unique and beautiful and you should feel great about your body. Try

this exercise to help you find peace with your physical self. The exercise is an excerpt from Nathaniel Branden's bestseller *The Six Pillars of Self-Esteem*.

An Exercise[2]

By way of introducing clients to the idea of self-acceptance, I often like to begin with a simple exercise. It can offer a profound learning experience.

Stand in front of a full-length mirror and look at your face and body. Notice your feelings as you do so. I am asking you to focus not on your clothes or your make-up but on you. Notice if this is difficult or makes you uncomfortable. It is good to do this exercise naked.

You will probably like some parts of what you see more than others. If you are like most people, you will find some parts difficult to look at for long because they agitate or displease you. In your eyes there may be a pain you do not want to confront. Perhaps you are too fat or too thin. Perhaps there is some aspect of your body you so dislike that you can bear to stay connected with the thoughts and emotions these signs evoke. So the impulse is to escape, to flee from awareness, to reject, deny, disown aspects of your self.

Still, as an experiment, I ask you to stay focused on your image in the mirror for a few moments longer, and say to yourself, "Whatever my defects or imperfections, I accept myself unreservedly and completely." Stay focused, breathe deeply, and say this over and over again for a minute or two without rushing the process. Allow yourself to experience fully the meaning of the words.

You may find yourself protesting, "But I don't like certain things about my body, so how do I accept them unreservedly and completely?" But remember: "Accepting" does not necessarily mean "liking." "Accepting" does not mean we cannot imagine or wish for changes or improvements. It means experi-

2 From the *SIX PILLARS OF SELF-ESTEEM* by Nathaniel Branden, copyright © 1994 by Nathaniel Branden, Used by permission of Bantam Books, a division of Random House, Inc.

without denial or avoidance, that a fact is a fact. In this case, it means accepting that the face and body in the mirror are your face and body and that they are what they are.

If you persist, if you surrender to the reality of what is, if you surrender to awareness (which is what "accepting" ultimately means), you may notice that you have begun to relax a bit and perhaps feel more comfortable with yourself, and more real.

Even though you may or may not like or enjoy everything you see when you look in the mirror, you are still able to say, "Right now, that's me. And I don't deny the fact. I accept it." That is respect for reality.

When clients commit to do this exercise for two minutes every morning and again every night for two weeks, they soon begin to experience the relationship between self-acceptance and self-esteem: a mind that honors sight honors itself. But more than that: How can self-esteem not suffer if we are in a rejecting relationship to our own physical being? Is it realistic to imagine we can love ourselves while despising what we see in the mirror?

They make another important discovery. Not only do they enter a more harmonious relationship with themselves, not only do they begin to grow in self-efficacy and self-respect, but if aspects of the self they do not like are within their power to change, they are motivated to make the changes once they have accepted the facts as they are now.

We are not moved to change those things whose reality we deny.

And for those things we cannot change, when we accept them we grow stronger and more centered; when we curse and protest them, we disempower ourselves.

Your Make-up

A model's make-up is an integral part of her job and serves different purposes. When you're interviewing with potential agencies or clients, keep your make-up minimal and fresh looking. "Less is

more," is how professional make-up artist Lisa Sim puts it. She does offer one must-do, however: curl your eyelashes to make your eyes look bigger and more awake.

Basic Make-up

You won't have anyone applying your make-up for interviews, so you'll have to master a few basics on your own. If you have nearly perfect skin, use mascara, eyebrow pencil, powder and lip-gloss. Okay, so you don't have perfect skin. Don't worry, that's where make-up can help. Sim says the best way to cover a blemish is to first apply a cream concealer, then blot the area with a tissue to leave the colour behind but remove excess oil, and dab a little powder on top to set it. Cream concealer comes in the form of a pencil, small pot or wand. If you need a bit more make-up to cover uneven skin or to have a more polished look, here's a simple routine:

(1) Apply cover-up under eyes and on blemishes; blend with a sponge.
(2) Apply foundation lightly all over face and neck; blend with a clean finger or sponge.
(3) Apply loose or compact powder with a large brush to seal in the foundation.
(4) Apply highlighting powder to accentuate your cheekbone (above the cheekbone) and brow bone (just below the eyebrow).
(5) Apply blush. You may apply it to the apple of your cheek for a fresh, youthful look or on an upward angle just below your cheekbone for a more elegant, chiseled look.
(6) Fill in your eyebrows, if necessary. You may use a brow pencil or a shadow with a small, shorthaired brush. A brow gel may also be very useful to tame unruly hairs.
(7) Apply eye shadow. On the crease of your eyelid, lightly apply an earthy colour like grey or taupe. On the lid (below the crease) apply a colour and then blend it into the crease colour.
(8) Apply a light coat of black or brown mascara.
(9) Apply and blend in a natural-coloured lip liner if you wish your lips to look fuller. Your lip liner should not show once your lipstick is applied; they should blend in completely. Apply a natural lip-gloss or lipstick.

Quick Model Tip:
Loose powder will give more complete coverage with a heavier coat. Compact powder with a big brush gives less coverage, but is much lighter and therefore appears more natural. It also has less of a tendency to accumulate laugh lines.

Quick Model Tip:
Make-up for fashion shows can vary widely. As a general rule, show make-up is less detailed and bolder than print make-up, not unlike theatrical make-up. You may use stronger colours and more contrast because of strong lights and your distance from the audience.

Bring a compact with mirror to castings to check your make-up and dab any areas that have smudged. Also, bring your lip colour in case you need to re-apply it.

Make-up on set

The second occasion for applying make-up is at a shoot. A make-up artist usually does your make-up, but you'll need to be prepared just in case one isn't hired. You must do your own hair and make-up at home if you're asked to come "hair and make-up ready." Your hair should be neatly styled but nothing too fancy. Bring a brush, hair spray and some hair accessories with you so you can accommodate the client's wishes. Your make-up should also be simple so that you can add more, if the client asks for it. Follow the same guidelines on the previous page, but use more powder so that you don't appear shinny. Carry a small make-up kit with you to make changes and touch-ups - bring powder, a couple of lipsticks, a blush and a few eye shadows.

Vancouver-based model, Suzie, always arrives at shoots prepared. She is often hired by a large Japanese catalogue company because she takes the time and makes the effort to bring small fashion and hair accessories and is able to touch-up her make-up to their specifications. As she has gotten to know the client, she can prepare her make-up in advance, just how they like it. Suzie's professionalism allows her to secure a great client's business.

When you're asked to arrive at a shoot with "clean hair and face," your hair should be clean with little or no product and no make-up. Your face should be free of residual make-up and should be well moisturized. Don't worry about blemishes. Make-up artists can cover them up much easier than they can dry skin. In fact, Lisa Sim says her pet peeve is "when models arrive at shoots with their make-up done." Your face is the make-up artist's canvas. Once she has applied her make-up, avoid touching your face. In fact, models often use straws to drink after their make-up is applied to minimize any change to the lipstick. Be respectful of the make-up artist's work.

There are several sources to help you learn about make-up and this guide is meant as a starting point. You might want to take a make-up course, either on its own or as part of a modeling course, especially if you're young and rather inexperienced. The beauty pages in magazines often provide lots of make-up tips suggesting current shades and practical techniques. Even ads and fashion spreads offer great photos of up-to-date make-up trends. If you're looking for more information, there are several great make-up books available. (See the reference section in the appendix on page 117.) However, the best way to gain skill in make-up application is through practice and lots of experimentation. Play with make-up and be creative!

Quick Model Tip:
Use Bioré Undercover Agent as a barrier over pimples. It medicates the zit and doesn't allow make-up in!

Quick Model Tip:
For on-camera auditions (commercials, film, television, industrial videos or music videos) your make-up should be done a little differently. Use very little eye shadow and chose subtle shades. Don't use any "sparkling" powders. Use plenty of face powder so that you don't appear shiny. Use "warm" colours especially for your lipstick. A lip colour that has an orange base (rather than purple or brown), believe it or not, looks much more natural on camera.

MODEL'S BIO

Sophie

Photographer: Pete Gaffney, Courtesy of: Modern Woman

Photographer: Bruno Petrozza, Show: Nadya Toto

How long have you been in the biz?
Fifteen years.

Where have you worked?
Montreal, Toronto, Athens, Hamburg, Milan and Paris.

How did you get started?
All my life people have told me I should be a model. Then there was an audition announced on the radio for a youth festival. I took part in the fashion show at the festival and took a liking to it. Later, I entered a modeling contest organized by *Clin d'Oeil* magazine. I didn't win the contest but I met a great agent.

Who are some of your clients?
I've done the designers' shows in Milan and Paris, as well as the designers' shows in Montreal and Toronto. I've done a few catalogues and I've done editorials in *Clin d'Oeil, Femme Plus, Marie Claire* and some European magazines.

Do you have any advice for someone starting out in the modeling business?

Be the best model that you can be by treating modeling like a job because it is a job. When you are a model, you're in business for yourself. Be prepared - be on time for castings and jobs, be well groomed, be manicured and pedicured, have perfect hair (no roots) and plucked eyebrows. Being prepared also means having cards to leave with a client. I have seen lots of girls at castings showing their portfolios and forgetting to stock up on cards. Remember: you're in business. Your comp card is your business card and no business card means no business. Keep yourself in top model shape and be on top of your business!

Do have a particular modeling experience you'd like to share with our young readers?

When I was starting in Montreal I was always being told I was "too tall" and I should go to Europe. (I'm 6 ft.) Once I got to Europe I was still told that I'm "too tall" until I slapped my book on a table in front of a client in Milan and said, "I was too tall for Canada and now I'm too tall for Europe. I'm perfect for this job, give me a chance and book me." I got booked for the job, which was a glasses catalogue, and then after that I got booked for shows, including one in Rome and some other catalogues. When I got home from Europe, the designers in Toronto and Montreal kept me working continuously for a couple of years!

What's the best part of modeling?

If it wasn't for modeling I would never have traveled and learned about different cultures. It is when you're away from the securities of your everyday life and everything you know that you learn who you really are and what you're made of.

CHAPTER 5

Model: Alex Coventry, Photographer: Bruno Petrozza

Chapter 5
The Main Course • Your Career

Testing

You need great photos in your portfolio to get a job. So, how do you get them in your book? You'll have do some "tests" - before you let out a big sigh, listen to the explanation. Tests are photo shoots designed specifically for providing you with great sample shots. Of course, you don't get paid for them because you're not working for a client in this case. In a sense, you're the client in a paid test. In a free test, also called a "creative," the whole team (model, photographer, hair and make-up artist, and stylist) all work without monetary compensation. That's because they all plan to use the photos for their own books. However, it's not unusual to pay for test shoots, especially at the beginning of your career. The advantage of paying is that you'll have a say on what you want out of it. For example, if you need a beautiful, classic head shot, also called a "beauty shot," you can ask the photographer to shot you in that way so that you get exactly what you and your agency need from the test.

In these photos, Patrick David and Nikki pose for great test shots.

After a test, you'll see contact sheets, smaller, thumbnail versions of all the different shots on one or several pages. Contact sheets allow you to see all your shots before making costly enlargements. From the contact sheet, your agent will help you chose the best photos to be blown up and placed in your book. Enlargements can be costly, but they're a necessity to get you fabulous photos in your book and eventually get paid bookings.

Jenny, a well-known catalogue model in Toronto had plenty of commercial photos in her book. She also wanted some editorial photos in her book to demonstrate to clients her versatility. She arranged

a test with a photographer to do an editorial-styled shoot. Throughout your career, tests can come in handy to update or diversify your book.

Before you do a test, plan it out with your agent and make a list of what you expect from it. Have your booker call the photographer to explain exactly what's expected. It's a good idea to use "tear sheets," which are photos from magazines pages, to help describe the look you're going after.

Throughout the planning, rely on the experience of your agent, but feel free to discuss your ideas to achieve concepts both of you like so you're comfortable with what's happening while you're on the set. You'll have to strike a balance between directing the photographer's creativity and applying your agent's expertise and wishes. Your aim is to have a variety of different "looks" so that clients can see your versatility, however, you don't want your photos to be so off the wall that a client can't imagine what you'll look like in her shot. As you get more experienced in the business, you'll learn more about your market and your desired look, ultimately playing a larger role in deciding what photos you need.

Working in a Team

You got the job! Now here's where your teamwork skills will come in handy. At a booking, there could be a variety of people present, from a photographer and assistants to hair and make-up artists to stylists and assistants to clients and art directors. Depending on the job, some of the same people could be on set. Here's one common scenario when shooting an advertisement: The client hires an ad agency to design their campaign. An art director from the ad agency creates a layout that involves a model. The art director hires a photographer. The photographer hires a hair and make-up artist and a stylist. Although the client and art director will usually already have an idea of what they want the model to look like, they'll hold a casting to review model books. The photographer is usually also present. The three of them will then select the model or models they wish to hire for the job.

Once you win the job, it becomes a team effort to deliver a final product to the client. While castings can be draining, you must persevere. Even the most successful models must go to many castings each week. It's easy to feel rejected if you don't get the job after a casting, but you can't take it personally. Remember, there are lots of models trying out for that one position. As you develop a stronger portfolio, count on seeing your casting-to-job ratio decrease.

Photo Shoots

The work a model does varies, from attending castings, testings, fittings (trying on clothes to check sizing), doing shows or shooting. Unless you're a show girl, the bulk of your modeling work is shooting flyers, brochures and catalogues, and occasionally, ads, magazine editorials, point of purchase material and packaging.

Be sure you're on time and prepared for a job. Arrange to get all the details from your agent the day before. You should know who the client is and what the shoot is for. You should know how much you're getting paid and what you're expected to bring to the shoot. As a precaution, always carry your agent's office and home number with you to a job in case there's a conflict. Your agent gets paid to do the negotiations, not you, so if a photographer or client starts to negotiate the details with you, immediately turn them over to your agent. The simple phrase: "Let me just give my agent a quick call so that you can clarify this detail with her" can usually resolve differences, and when it doesn't, you can pass the phone over so your agent can speak directly to the client.

Payment Info

You're likely to have already done a few shoots for free at the beginning of your career, so be careful if clients try to take advantage of you. As a general rule, if a client will be using your photos for promoting and therefore selling their goods or services, they should be paying you for your modeling services. However, it might be worth considering doing a job without pay if your agency recommends that you do the job because you could benefit from the experience. A client might offer to pay in products or clothing, but this rarely happens. When a client has hired you to do a specific job, like catalogue

modeling, you're usually paid by the hour. Some jobs will pay a day rate, which is a rate for the eight hours or less that you're at the studio or on location. Like hourly-wage earners, you should expect overtime after eight hours. In some cases, models receive a flat rate (but none of these rates would include the usage of photos for the purposes of advertising). For instance, fashion shows often pay a flat rate that includes fittings, rehearsals and your work at the show. A flat rate might also be paid for a trip job (a shoot done on location, outside the city where the booking originated). While these types of rates are all common in North America, rates vary greatly in Europe and Asia. For instance, in Osaka, Japan, many jobs are billed per outfit modeled. If you're not sure about billing, **ask your agency to clarify the details - you'll both be happy you did.**

When comparing a model's hourly wage, models earn more than young people in typical jobs, but models will often work with no compensation (i.e., at castings and testings). Just like running your own business, models are also not normally entitled to health benefits and job security. (See info about model's rates in Canada in the section on Canadian Markets on pages 92 and 93.)

Location, Location, Location Jobs

Most bookings will take place within the city you work. Very often models, whether beginners or experienced, will be fortunate to get jobs that take them to exotic locations, such as Florida, Mexico or Hawaii. Often bathing suit catalogues and sometimes magazine editorials are shot "on location." Models may also get "direct bookings" - when a client from one city books a model to travel to that city for the job. In this case, the client pays for the model's time and expenses. Generally, only experienced models with very strong books get the opportunity to secure direct bookings.

At the location (studio or outdoor location), a make-up artist and a hairstylist will spend about an hour getting you ready. Ask your agent whether you should be billing a full or half rate for this first hour that you are "working," since this billing hour varies between cities. Following this prep time, you'll be asked to try on clothing and begin shooting - during this time you'll be billing full hourly rate.

Smile, You're On Camera!

There are many details to be aware of when you're shooting, but you usually have plenty of help. You can count on the photographer to give you pointers and later, with experience, it'll become second nature. If moving in front of the camera doesn't come naturally, practice it at home in front of a mirror.

Moving in front of the camera also means knowing your good sides, how to smile and conveying different emotions or looks. Sometimes, there's one side of our face that looks "better" than the other - use it when possible. Catalogues usually want to achieve a look that is friendly and approachable. You never want your smile to look fake, so practise achieving a smile that's both sincere and beautiful. Sometimes it helps to literally laugh out loud while you're smiling. A good smile, unless you're expected to show a big laugh, shows no gums above your top teeth and no or few bottom teeth.

Editorial shots are usually "moodier" than catalogues, where models are required to show subtle emotion with their eyes. Editorial poses are often more dramatic and "artsy." Some clients like a slightly posed look, while others prefer a more relaxed shot, sometimes call a "lifestyle shot." A lifestyle shot or look focuses more on the mood of the whole shot to convey a certain lifestyle. To see some of the differences between types of shots, refer back to the "Types of Models" section on pages 17 thru 19 and examine the models and poises in each photo.

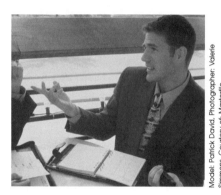

When a viewer sees a lifestyle shot, she wants to take part in the photo, in the lifestyle.

Model: Patrick David, Photographer: Valerie Simmons, Courtesy of: Masterfile

The Right Fit - Clothes

You always want to show off the clothes (assuming that's what you're modeling) in the best way possible while looking natural. Sometimes, it can be physically challenging depending on your position or location, for example, if the coat or gown is heavy or if you're standing on rocks.

A native of Saskatchewan, model Sara, took up Yoga to help her improve her modeling career. Not only is Yoga great for general well being and as a stress reducer but it helped Sara hold difficult poses with ease. Sara used the practice of Yoga to breath and balance postures while she modeled in the studio and on location.

Sophie moves with such fluidity that her photos are graceful and dynamic at the same time.

Model: Sophie, Photographer: Settimio Benedusi

Experiment with different postures in front of the mirror to see which positions flatter you and your clothes best. You may practise using your hands and arms in different ways, as well as changing your leg positioning and weight distribution. **There are no limitations to your movements!** Keep a magazine and a catalogue nearby while you're practicing so you can mimic the models' poses. Practise until you become comfortable in different positions.

There are other ways to learn movements - there are a variety of dance, movement and improv courses. Such courses help you shed some of your layers of self-consciousness and become comfortable with your body and movements, allowing you to move with ease and grace in front of the camera while a half dozen people are watching.

Using Props

Props can help you nail down a certain pose. If you browse through magazines and catalogues, you'll notice how the models use their collar, baby, animal, another model, a wall, bench, ledge, tree, sporting equipment, gloves and accessories like a hat or gloves to their advantage. One good trick is to use the prop to make you more comfortable - think of what you're really doing. For example, if you're in athletic gear and you're supposed to look like you're doing a push-up, then do one or a few until the photographer captures your best angle.

Montreal and Toronto model, Kelli, uses her athletic body to her advantage to score many jobs for sportswear companies. One of those clients often hires her for her athletic looks and abilities. For one

job, Kelli ran on Mt. Royal and skied down Mt. Ste. Anne for the client's summer and winter catalogues respectively. Clients chose Kelli to get sporty photos that look less posed and more realistic.

If you still need more practise moving in front of a camera, ask a friend to shoot you - now's the time to call in that long-awaited favour. Shoot either with or without film just so you can practice moving for each "click" of the camera. The advantage to using film is that you'll be able to see which poses work best, even though it may cost you a few dollars more. This is a perfect opportunity to borrow a digital camera since there's no cost for film or developing and you can upload the photos immediately on your computer. Don't be upset if the photos don't look perfect or aren't great quality - your friend isn't a professional photographer.

Fashion Shows

Another common booking is a fashion show. Designer shows are usually held in Montreal and Toronto for one week in September and one week in March. But most markets, big and small, provide plenty of opportunity for jobs in other fashion shows. Department store, boutiques and malls all have a variety of shows throughout the year.

To walk on the catwalk you need poise, grace and confidence. Well-known Canadian runway model Sophie (see Sophie's "Model's Bio" on page 68), explains that to walk in a show you must do so naturally but with elegance. The secret is balancing your hips - move one hip forward as you extend that leg and then as the other hip and leg come forward the first hip moves backwards, almost like you're outlining crescent shapes on either of your sides with your hips. Sophie recommends that you find a focal point that is slightly above the audience - don't look down or at eye level because camera flashes will distract you. Sophie's mantra is: "Take possession of yourself and your space" and you will walk with poise and confidence.

The best way to learn to "walk" is to take a class or private lessons. Study how models walk by watching fashion shows on TV. Different shows require different "walks" and different attitudes - a model's walk for a designer show in front of buyers and magazine

editors is different from the walk she uses for a show at a family-oriented department store. The more fashion shows you watch, the better you'll master the attitude for different shows.

These great models show confidence and style while 'walking the walk' at Montreal shows.

Vouchers

Every job requires you to fill out a "voucher," a record that contains details of the job, along with the client's signature. A voucher form is copied in triplicate - one for you, one for your agency and one for the client. Sometimes the photographer will sign on behalf of the client if he or she isn't present at the shoot or if the model was hired through the photographer. You can simply ask at the end of the job, "Who can I get to sign my voucher?" Make sure you always get a voucher signed so there's a record of the time you've worked. The only exceptions in large Canadian markets are at fashion shows and sometimes on trips where you're paid a flat rate. Ask your agency about vouchers every time you work in a new city. For instance, in Hamburg, Germany, agencies don't use vouchers. Just to be safe, when in doubt, get a voucher signed. And even when a voucher isn't required, it's a good idea to always record all the details of your

work in your day-timer: the hours worked, the name of the client, name of the photographer and the amount billed - this information can be useful down the road.

When you're filling out a voucher, document details as accurately as possible. All agencies have different looking vouchers, but you should make sure they include your name, the date, the time you worked and your rate along with a signature. If a client disagrees with your rate, which shouldn't happen since it should have already been negotiated with your agent, don't argue or try to negotiate. Just have them sign for the time worked and let your agent discuss it afterwards.

Releases

A release is a legal form giving the client or studio permission to reproduce your image in any format they wish, such as on a big billboard that your parents see every day on their way to work. Never sign a release without first asking your agent - signing one gives clients permission to use your image without compensating you or your agency. If you're not sure what to do, ask the client to fax the release to your agent and then discuss it with your agent.

As a model in Canada, the current copyright laws protect you as long as you don't sign a release. Without a signed release, clients usually pay each time they reproduce your image. They initially pay for your time (an hourly or daily rate) and then for the use of the exposure for advertising purposes. However, there's **no** usage fee for magazine editorials, catalogues or flyers. If you sign a release, a client is entitled to use your image for lucrative opportunities as billboards, bus shelters, magazine ads and packaging, where you'd normally make a considerable income. If a client insists you sign a release, they're likely hiding something from you.

Here's just one of the many stories about a model thoughtlessly signing a release and how it hurt her. Betsy did a very small shoot for one shot to be used in a flyer/brochure, which paid no usage. After this shoot, she accidentally signed a release even though she was an experienced model. She soon noticed the photo being used in

brochures, posters and packaging! She was stunned but she thought, "No problem, I'll have my agent bill the client for usage." The photo studio had the original release that she signed, which essentially agreed in writing to allow the company to use her photos without compensation. Betsy and her agent went to small claims court and they won, but the hassle of going to court could have been avoided.

Why not work up a sweat on your summer vacation?!
These photos are from a catalogue shoot
in the Seychelles (islands off the east coast of Africa).

Here's the author really enjoying her work!

Traveling Around

Although there are many opportunities for work in Canada, it's common for a young model to travel to Asia and Europe to gain experience and make some money. Besides, developing a portfolio abroad can offer a model more opportunities in Canada and the U.S. later on. What's appealing about these two markets is their access - Asia, for example, is open to beginners and comes with little financial risk because models are given contracts guaranteeing a certain income; as well, their flights and accommodations are pre-paid by the Asian agency. 'Pre-paid' doesn't mean the model won't pay for it, rather, the agency will front the cost and then deduct it from the model's subsequent earnings. Europe is a very large market that boasts many opportunities for beginners to work in magazines, catalogues and commercials. One of the single greatest benefits of modeling is the opportunity to travel around the globe, so take advantage of it. It's a wonderful chance to meet new people, learn about different cultures and create memories that will last forever.

Which markets are best for you? Each season the demands within a market change. You'll have to work with your mother agent to find where there are opportunities for you. Usually, the bigger the market, the more opportunities that are generally available to a model. But, that's not to say that the biggest market is always the best way to go - in some instances, smaller, lesser-known markets can be lucrative. Lauren was a beautiful model who spent a great deal of time working in Athens. In a relatively small market, Lauren became a big fish in a small pond after spending some time there. She was able to make and save money shooting several commercials, modeling for some catalogues and many magazines, including the prestigious *Elle* magazine. Ask your agent for guidance on the best market for you. Of course, any overseas market offers a wonderful opportunity to travel and experience other cultures.

When traveling abroad you must be prepared to work and live in a foreign city. The first question you must ask yourself is: What does the new agency expect of me? Find out from your mother agent what you need to bring with you. In any market you'll have to travel with clothes for castings but some markets have specific requests.

There is also the personal side of traveling to keep in mind. When traveling to any country you should also be sure to bring a sufficient supply of toiletries. Some cosmetics, hair products and even feminine hygiene products can be very different abroad and you don't want to be without your regular products. As for security, it is a good idea to bring a lock for your suitcase so that you can lock away your earnings and valuables.

Quick Model Tip:
In Tokyo and Osaka, models must bring a large selection of shoes with them. Women need to bring: white, black and tan heels, brown and black flats and white sneakers. Men need to pack: black and brown loafers, black and brown dress shoes, boots and white sneakers. Don't blow your budget for this kind of request, instead borrow shoes from friends for the month you'll be in Japan and/or buy a couple pairs on sale from Payless Shoes, Walmart or Zellers.

When you arrive in a new city you will usually take a taxi from the airport directly to the agency. If you arrive after business hours, you should proceed directly to where you'll be living. (Know when you're arriving and get all the appropriate addresses from the agency.) You'll probably be staying at a model's apartment (a condo owned by the agency and then rented, usually weekly, to models) or a hostel where many of the other models will be staying. Use the models you're living with as a resource and ask them how to get around, where to change money and where to buy groceries. It is always a good idea to arrive with local currency; enough to get by for a day or two.

On your first full day in a new city you will head to your agency first thing. They will either provide you with a map or tell you which map is best and where to buy it. Your map will be your best friend, so don't use it to swat the mosquitoes! The first time you're at your agency is a good time to send a fax or e-mail to your mother agency telling them you've arrived safely. Your agency will then need colour copies of your book

if they don't already have them so you'll be off to the photocopy shop. Once you're organized with your portfolio and comps, your agency will give you appointments for go-sees and castings.

Getting around foreign cities can be frustrating. Please be patient and don't freak out! Use your map and ask for directions. You'll have to learn about the public transit in that city so that you can get around efficiently, but some cities are more organized than others. In Paris and London, you'll use the subway to get everywhere. In Milan, you'll use the subway and trolleys. Some cities will allow you to walk and see the sights where other cities you'll be underground.

One note about being paid in other countries: Make sure you get your money before you leave the country. The money you make while you're there is yours and you deserve it. Most agencies have a lag time between when you do the job and when you'll get paid. Let's say it's four weeks. What this means is that when you leave the country you will not get your money for any jobs done in the pervious three or four weeks. Most agencies will let you take the money early but will charge five to ten percent extra for advancing you the money. Unless you've worked with the agency many times before, take your money when you leave even if it means losing a small percentage. It is just too difficult to track down an agency from the other side of the world should anything go wrong.

Each city you visit will be a new and wonderful experience, try to use the weekends to explore the tourist attractions as well as the local hangouts. And don't forget your camera; you'll see some amazing sights!

Cristy McNiven

How long have you been in the biz?
Five years.

Where have you worked?
I've worked in Vancouver, Los Angeles, Miami, New York, Milan, Paris and Sydney.

How did you get started?
When I was 14 years old, someone from a small agency in Kelowna, B.C., stopped me on the street. The person didn't want my Mom involved at all, so I didn't pursue it, but it got me interested in the business. Then I went to a convention, met a scout and three weeks later went to New York with a great agency.

Who are some of your clients?
I've worked for lots of the teen magazines in New York, but mostly I've been in Europe where I've done runway shows, catalogues and magazines.

Do you have any advice for someone starting out in the modeling business?
1. Find a good mother agency because it will be fair and have better contacts to hook you up to other agencies.
2. If you're under 18 years old, get someone to travel with you.
3. Don't expect it to happen overnight. You need to persevere and put your time in it.

Do have a particular modeling experience you'd like to share?
The coolest job I had was for the closing ceremonies of the Salt Lake City Olympics 2002. They were doing an introduction to Italy for the next winter Olympics so they had a fashion show featuring Versace, Valentino and Dolce & Gabana. My dress was solid beads, backless and weighed about 50 pounds. It wasn't the winter collection! Plus, I had on stiletto heels that were a size too big. And, it was minus twenty outside and the platform was slippery. Despite all these conditions, it was magical when I walked into the stadium. After the show I called my Mom right away and asked: "Did you see me?"

What's the best part of modeling?
Without question, the best part of modeling is the traveling. I've seen so many places I never would have experienced otherwise. Once in the middle of winter, I got to shoot a bathing suit catalogue in Hawaii and they brought my Mom along too! Another time I went to Paris for a job and because I was young they paid for my Dad too - it was his first trip to Europe. Even if there's a difficult job, at least I get to see another neat location.

What's the worst part of modeling?
For me, it's the unreliable nature of the work. You never know if you're going to work this month. It's stressful. After Sept. 11th, I went to London and I wasn't working at all, but then a month-and-half later, I was in Miami working continuously. It's so unpredictable.

Acting

As a model, you may also get opportunities for other exciting work - for example, auditions for commercials. Vancouver, Toronto and Montreal each offer their fair share of acting gigs since many Canadian and American production companies shoot in these cities throughout the year. Also, smaller cities, like Calgary and Halifax, are becoming more popular for TV and film productions. Directors for commercials that need a tall and/or pretty girl usually request models. If a model is requested, your agent will send in your comp card.

If making commercials interests you, ensure your agent is submitting your photo to the casting directors for consideration. For most acting jobs, you're required to hand in an actor's headshot instead of your comp cards. If you're more serious about acting, you should have proper acting headshots taken. This type of photo is usually in black and white and looks like "the real you" with minimal make-up and lots of expression. Along with a photo, your agent will submit your resume to highlight your previous acting jobs, any classes you've taken and any special skills/activities, such as any sports you excel in.

Jennifer's headshot is naturally pretty with minimal make-up and hair styling and most importantly, her vibrant personality comes through.

Lisa's headshot is also striking as she wears her glasses to show some character and individuality.

Commercials can be a fun and challenging experience, as well as a great source of income. Among the clients looking for models in their commercials are companies selling cosmetics, skin/body products, cars and clothing stores. Once you have a little experience in commercials, you'll have a stepping-stone to venture into film and television acting, if you desire.

ACTRA

Some commercials, film and TV jobs are considered union jobs and are governed by the by-laws of ACTRA (the Alliance of Canadian Cinema, Television and Radio Artists), the Canadian actor's union. In British Columbia, ACTRA is called the Union of B.C. Performers (UBCP). There are advantages and disadvantages to joining the Canadian acting union, but if you hope to focus on commercials or peruse acting in any way in the future, you'd be smart to join the union earlier. A union production must first attempt to hire union actors, and only when it can't find the "right" person can the company hire a non-union actor. And conversely, once you're a union actor, you may only work for union productions.

ACTRA has a multipart structure with a division for commercials and another for other productions with hundreds of by-laws that can affect one of your jobs. Make sure you read all the ACTRA literature before your first ACTRA job so that you know what to expect. Although most of their books and pamphlets aren't too difficult, your agent can help you with deciphering any jargon.

ACTRA has a Commercial Agreement and an Independent Production Agreement to ensure rates and conditions are at certain minimum levels for commercial and all other productions respectively. What these agreements mean is that ACTRA has predetermined your rate for billing. Most commercials and acting productions are done "at scale" which is the minimum base rate for a job. On occasion your agent can negotiate a higher rate based on the scale, such as "double scale." The working conditions are also set out, such as how many hours can be worked before a meal must be provided and at what point overtime is billed. Also, ACTRA jobs must be paid to the actor within a set amount of time, which means that you'll be paid faster for acting jobs than modeling jobs.

For French language projects, ACTRA is replaced with a union called Union Des Artistes (UDA). In the United States, the unions are The American Federation of Television and Radio Artists (AFTRA) and the Screen Actor's Guild (SAG). If you are working in either of these jurisdictions, you may join these unions instead of or as well as ACTRA.

The easiest way for most Canadian models to become members of ACTRA is by joining its Apprentice Program. The following is an excerpt from ACTRA's Guide for Professional Performers:[3]

There are FIVE simple steps to becoming a full member through the apprentice program:
(1) Land a SPEAKING role in a film/TV series/movie-of-the-week or a speaking role/silent on-camera (SOC) in a commercial.
(2) Buy a work permit from the ACTRA Toronto membership department (or your nearest ACTRA office, see appendix on page 109 for the complete listing) and tell them you want to register as an apprentice member. You then pay an initiation fee of $30.00, attend an apprentice members' meeting at the ACTRA building and receive you apprentice members' card.
(3) Accumulate FIVE additional paid work permits - not from background roles (or two additional work permits it you are a visible minority or differently-abled).
(4) When you purchase your sixth permit (or third in the case of minority/differently-abled status) tell the ACTRA membership department that you want to become a full member. Pay your initiation fee ($300) and 1/2 a year's dues.
(5) Attend a full members' meeting and receive your ACTRA card!

Although being a member is costly, the payback can be well worth it. Apprentice and full members are given priority for union jobs that pay much more than non-union jobs and require producers to adhere to certain by-laws, such as working conditions and paying workers within two weeks of shooting. Full ACTRA members pay basic dues each year and a percentage of their gross earnings up to a maximum. Apprentice members pay an initiation fee plus a fee for each of the work permits they require. The cost of these work permits depends on the roles they are cast in. Apprentice members must pay another initiation fee and half a year's dues to become full.[4]

The sooner you can become a member the better - while you're an apprentice, you must pay 10% of all commercial residual payments to the union. (You make no payments to the union for

3 and 4 From *The Guide for Professional Performers in the Recorded Media: Members Resource Guide.* Version 3.0, copyright © 1999 by ACTRA Toronto Performers.

residuals if you're a member - although ACTRA is proposing this by-law be changed.) To make the jump to a full member, you're required to have six credits, which can be difficult to obtain. Ask your agent and your local ACTRA office for ideas on acquiring them. For example, one way to get a credit is by participating in a special ACTRAWORKS course. ACTRAWORKS is the national training division of ACTRA. The requirements for becoming a member of the UBCP and the UDA are similar. Visit their websites or call their offices for details (see the appendix on page 110).

ACTRA and its affiliates work to regulate pay scales and working conditions. By being a member of the union, you'll be protected under their by-laws and have a useful resource. For the self-employed, one great membership benefit is the access to health, dental, accident and death insurance.

Auditioning

Before you land a commercial or acting role, you'll first have to audition. The client (i.e. an ad agency or a producer) will hire the "talent," also known as actors or models, through a casting director. Sometimes casting directors are also used for modeling shoots when a client is coordinating a print advertisement. The casting director figures out exactly what look and qualifications are needed in the talent, and then sends out a breakdown of these details to agencies. An agency will then send submissions (a comp or a glossy photos and resume) for consideration to the casting director. From the submissions, the casting director will choose the models and actors. Only a handful of applicants out of several hundred actors will get an audition.

Quick Model Tip: *Under ACTRA rules all performers will make union wages but specific by-laws pertain to the well being of those performers under 18 years. Examples of these exceptions include: working schedules, parental presence, tutoring, and a trust account once the child's lifetime remuneration reaches $5000.*

What to wear

Once you get an audition, you'll be required to perform in front of two or three people. Your hair and make-up should be specific to the "look" the casting director wants - ask your agent for help here. For instance, a 15-year-old girl who is a basketball player advertising cereal would look different than a 15-year-old girl going to a prom advertising breath mints. Your clothes should be appropriate for the age and occupation of the character and for the activity being featured in the commercial.

As for clothing, aside from wearing what's appropriate for your role, you'll want to stay away from white, black or very bright colous for technical reasons. If you wear white, for example, the light will reflect and wash out your face. Black absorbs light and your face will appear dark with shadows. And, bright colours tend to reflect those colours onto your face. If you must wear one of these colours, such as black, wear a garment that doesn't cover your shoulder or that's low cut so it's as far away from your face as possible. Another trick is to wear a scarf or sweater over your shoulders so that a different colour is next to your face. The best colours on video are medium to light greys and pastel colours.

Getting Ahead

You'll also want to make a good impression by being at least 15 minutes early to an audition. Once you find the office, check your make-up and clothes in the washroom, sign-in with the receptionist and fill out a standard audition form. You may also be given an outline of the commercial so that you can prepare for the sorts of things they'll ask you. For example, you may have to look curiously at a car; scream as though you just won the lottery; or dance at a party - whatever it is, don't be shy. Some auditions will require that you learn a few lines.

You can spend years learning acting and audition techniques, but here are a few definites:

• **Memorize all your lines.** When practising your lines, do them with many different intonations in your voice and in front of a few different people or a mirror. This way you can internalize the lines in dif-

ferent environments and get over the nervous factor of speaking in front of others.

• **Do some improv exercises.** When you get to the audition it can be very nerve-racking. So, just before you get called in, try some exercises improv comics sometimes use. Shake your wrist so that your hand is flinging back and forth. Once you relax one part of your body, the rest is apt to follow. Also, take big, deep breaths from your belly to help you relax and regain focus. Find the techniques that work best for you.

• **Practise slating.** In the audition room, you'll be asked to slate, which entails saying your name and your agency while looking directly at the video camera. You may be asked to show your profile and hands. Appear friendly and speak clearly while you're slating. Finish with a nice smile. The camera operator will usually take a still photo of you with the video camera at the end of your slate.

• **At the call back, wear the same clothes you wore to the audition.** After you audition, you could be one of the lucky few that gets a call back to perform the audition a second time.

• **Be yourself!** At the call back, several people may be present, including: the casting director, producer, client and director to watch you act as you either shop, listen to music, dance or walk your dog. Some people say the director already knows who they'll hire before the call back and that this step is just a formality. But don't stress out. If you're a union actor, you'll get paid $25 for your expenses and time for doing a commercial call back. The payment is not subject to agency commissions, union fees, or RRSP deductions. If you get the commercial, congratulations! If you don't, don't spend your 25 big ones all in one place!

The Canadian Market

Arguably, the largest markets in the world are outside Canada, but there can be some great opportunities in your backyard. Canadian markets can be especially beneficial for models who are

too young to travel outside the country and for those who have solid books. Here's a breakdown of some of the largest Canadian markets, according to some agents.

Quick Model Tip:
As a rule, modeling babies and kids make less than their "Moms" and "Dads." Kids make about half of the adult rates. When babies shoot for catalogues in Toronto "two babies are always booked...just in case," explains booker Rhonda Croft. The "primary baby," the one actually used, is paid $50 an hour and the "back up baby" bills $25 an hour. But Croft warns, "You don't know which baby you have until the end of the shoot."

Toronto

It's the biggest modeling market in Canada. Toronto's market is diverse and includes catalogue, editorial, runway and advertising clients. Elite's Alecia Bell says "Toronto has models that live and work full-time in Toronto, as well as models who work for a season or two, then move to large international markets like Paris or New York. Our Toronto agency represents full-time models who work with Canadian clients and direct book into the U.S. and European markets. It's a very busy market and the film industry is booming." Basically, "it's a great market, with great talent and great rates." In Toronto, fashion show rates vary between $120 and up an hour or $350 to $1000 for a package that includes fittings, rehearsal and shows. The rate for shooting catalogues such as: Sears, The Bay and Zellers in Toronto is $110 an hour while other catalogues and advertising rates are between $150 to $250 an hour, depending on the model's experience. Editorial rates vary, depending on the publication, between $100 to $300 per day.

Montreal

Montreal is the second largest market with highly regarded fashion magazines including: *Elle Québec, Clin d'oeil,* and *Ocean Drive.* The city also plays host to many top Canadian designer runway shows like: Dubuc, Nadya Toto, Marie St. Pierre and Yso. Some catalogues and advertising is also shot there.

Giovanni Models booker, Isabelle Laisné, describes the city: "Many models live in Montreal, but most come for a short period of time to build their books with great local photographers." Montreal also benefits from English and French commercials, TV and film projects. Fashion show rates are between $150 and up an hour or $250 to $500 for a package. The rates for catalogue and advertising are between $160 to $275 an hour with a four hour minimum, while editorial rates range between $150 and $300 per day.

Vancouver

Vancouver offers a very small market to models. Very few local models make a living remaining in the city, however the city boasts the largest TV and film market in Canada. Richard Hawley, of Richard's International Model Management, describes Vancouver's editorial market as very limited since there are so few magazines in the city. But, he adds that "lots of Vancouver's market is catalogues from Japan, Germany, the U.S. and other places in Canada." The catalogue and advertising rates in Vancouver range from $125 to $200 an hour with a two hour minimum, with the editorial rates from $250 to $350 per day.

Other small markets

Other small markets in Canada can provide opportunities for beginners to gain experience and make a little part time cash. Often malls and locally owned stores shoot flyers and posters in the area. Usually malls and convention exhibitions (like bridal shows) hire local models for fashion shows. Most small markets either don't pay for models or pay less than what would a large market. For example, a package for fittings, rehearsals and a few shows over a weekend convention may pay $75 to $250.

Each city you visit will have a different set of rates. SPECS Models booker, Manoushka Ross points out that "the reason the editorial rates are so much less than the commercial rates is because the editorials are prestigious to do and increase your exposure and experience, which will then increase your commercial rate for catalogues and advertising."

MODEL'S BIO

Kalyane Tea

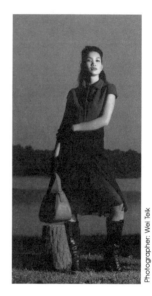

Photographer: Wei Telk

How many years have you been in the biz?
Three years.
Where have you worked?
In Montreal, Toronto, New York, San Francisco, Hong Kong, Kuala Lumpur, Singapore and Tokyo.
How did you get started?
Many people were telling me I should be modeling, but I wasn't ready and confident enough to make the first steps. Then I started working with a casting agency doing extra work - "extras" are the actors in the background of a scene. The same agency had opened a modeling division and wanted me to try working for them. It was that agent who made me realize that there was a market for my look. From that experience, I started to make my way up to bigger agencies and eventually to traveling.
Who are some of your clients?
Some of the designers I've worked with are: Nadya Toto, Yso, Dubuc, Hugo Boss, Rudsak, Cartier and Fendi. Some of the stores I've worked for are: The Bay, Holt Renfrew, Ogilvy,

Macy's, San Francisco, Garage, Guess, Parasuco, Suzy Sheer and Marks & Spencers. I've also worked with cosmetic companies, such as Mary Kay and Lise Watier along with lots of magazines, including *Marie Claire*, *Bazaar* and *Glamour*.

Have you done any commercials or film & TV work?

Yes, lots! In the modeling business you get to work in so many different environments - it's a great learning experience...if you pay attention! In Canada, I shot a Smirnoff Vodka commercial and, in Hong Kong, I did one for the Standard Chartered Bank. In Singapore, I did a commercial for the May Bank where I got to be Laura Croft for a day! I've been in quite a few films, including *Beyond Borders* with Angelina Jolie, *The Arrival* and *Afterglow*. I've also been in music videos for Daniel Bouché, One Tone and Mélanie Reaud. I've also been in a few TV shows, including: *Trendspotting, Paparazzis, Diva* and *Student Bodies*.

Do you have any advice for someone starting out in the business?

The most important thing is to have good self-esteem. What I mean by that is: don't be afraid to be yourself and don't let anyone you don't trust influence or control you. After all, modeling is just a job.

What's the best part of modeling?

Well, there are a lot of great things about modeling - the diversity of the jobs, being your own boss, working in a creative environment, meeting a lot of different people and the money! But, I would say the best part for me is the traveling. I enjoy being able to move from one city to another and fully living in the lifestyle of each of them. This experience has been very powerful as it made me see how diverse the world really is.

What's the worst part of modeling?

It can be difficult to be judged on your physical self, which is only part of who you are. Some people have negative preconceptions about models and may treat models accordingly. There are the classic stereotypes: they don't eat, they're very easy-going and party all the time and they're not very intelligent. The person who takes these generalizations seriously must not know any of the successful Canadian models I know!

CHAPTER 6

Model: Winter Lunde

Chapter 6
The Bill • Your Accounting

You've worked really hard to do your best modeling work, and now it's time to collect on a job well done. The good thing is, you've got your agency doing most of the legwork for you. All you have to do is submit one copy of the voucher to the agency and its accountant will bill the client appropriately. Remember, the voucher is a record that contains details of the job, along with the client's signature. The invoice the agency sends will include a fee for your work, the agency's fee and the applicable taxes. But don't make shopping plans right away - clients will typically have 30 to 60 days (depending on the city) to pay the agency. Once the agency receives payment, it will need to process the cheque and then you can expect to get paid on "pay day," which is either two or four times a month (depending on the agency's schedule). It's so easy to loose track of payments, which is why you'll need to keep a good record on your own. This record keeping is called "bookkeeping."

Here's where your math skills will pay off. When the agency sends you your cheque, you'll see a deduction for its commission from the amount you billed. In Canada, most modeling agencies charge their models a 20% commission. The commission is not to be confused with the agency fee, which is also 20%, but it's billed by the agency directly to the client. Both the model and the client must pay the agency for their services in most Canadian markets.

You might want to seek the advice of an accounting professional and a financial planner for more information on how to track your bills and invest them for future savings. But read this first!

Income Taxes

Oh Canada - if you live here, you can't escape paying taxes on the money you earn. So, if you make any money at all, it's a good idea to file a tax return to Revenue Canada on or before April 30 each year for the preceding year. Although you don't have to file a return if you make under a certain amount, it's advisable that you do it anyways. Don't worry, just because you file a return doesn't mean

you'll owe the government any money! It's advised that you hire an accounting professional such as a chartered accounted, a certified general accountant, a certified management account or a tax filer to file your taxes. A professional can do it in a timely, efficient and effective manner. According to Revenue Canada, "A sole proprietor pays taxes by reporting income (or loss) on a personal income tax return (T1). The income (or loss) forms part of the sole proprietor's overall income for the year."[5] In other words, even though you have a business, you only file one tax return annually. As a business owner, you're entitled to writing off expenses from the money you earn, but figuring out what and how much to write-off can be tricky so it's a good idea to hire the assistance of a tax advisor. If you're extremely organized, meaning you've kept and recorded all your receipts, the fee for these services will be approximately $50 to $200-plus, depending on the complexity of your tax return. Even though you work through an agency, you're considered self-employed. For tax purposes, this means you are the "sole proprietor" of your own business. It is not necessary to register your business because, essentially, the business is your name. On your return you will specify that you are self-employed and the nature of your business - these are some of the details that your tax professional will incorporate into your return.

The Goods and Services Tax

GST is a 7% Canadian tax applied to goods and services, and yes, that includes modeling services. "As a sole proprietor, you have to register for the goods and services tax/harmonized sales tax (GST/HST) if your worldwide annual taxable revenues are more than $30,000."[6] Therefore, if you expect to earn close to or more than $30,000 a year worldwide, you must file for a GST number. Since you can't predict your earnings as a model, you may wish to collect GST as a precaution. Even if you earn less than $30,000 there is the additional advantage of having a GST number that if you're collecting GST you can get a refund on applicable purchases - in other words, you can apply the GST you've paid on business expenses to the GST you've collected and possibly get a refund on the GST you've paid.[7] If you earn anything below this amount of $30,000, you're not

5 and 6 Taken from the *RC4070 - Guide for Canadian Small Businesses* (page 6).
7 Taken from the *RC4070 - Guide for Canadian Small Businesses* (page 13).

required to charge GST on your services. Your agency will charge clients GST on your behalf and you'll be responsible for submitting it to Receiver General (part of the government). Your agency will also be charged GST on their commissions.

If you reside in Newfoundland, Nova Scotia, and New Brunswick, you'll need to be aware of the HST. It's a 15% tax that combines the provincial and the federal GST taxes. Therefore, if you live in these maritime provinces, you must charge the HST if your worldwide income is more than $30,000. Other provinces require models to also charge the provincial sales tax if you are earning over a certain level, such as Quebec (known as the Quebec Sales Tax, the QST). While your agency will charge your clients for your time and the appropriate taxes, you'll need to provide it with your GST/PST/HST number(s) when applicable, so that it can collect it on your behalf.

To register for your GST/HST number, go to your local Tax Services Office and fill out a RC1 (Request for Business Number) so that you can receive a BN (Business Number). In Quebec, you should contact Le ministère du Revenu du Québec at (800) 567-4692.

For more information on income tax and GST/HST, refer to the Guide for Canadian Small Businesses. This publication is available online (see the online reference section in the appendix on page 119) or can be ordered by calling (800) 267-1267. Another good resource is Reference Canada at (800) O-CANADA (622-6232).

Bookkeeping for Smarties

To make your life as an entrepreneur as easy as possible, keep extremely well-organized records. You need to save and clearly label all related receipts to your work for up to seven years in the event that Revenue Canada investigators audit you to verify your records. If you get audited, you'll be glad you hired an accountant to assist with your return, and you may want to hire them again to help you through the process. If you detest bookkeeping, you

Quick Model Tip:
Did you know that the words "bookkeeper" and "bookkeeping" are the only words in the English language that have three continuous sets of double letters?

can hire a bookkeeper or maybe a trusted friend, Mom or Dad can take care of this initially. However, if you can dedicate some time to the task, it isn't very difficult. Try this method: Label large envelopes with the category and the year. Here's a listing of some of the categories and a few of the items you need to include in each envelope:

- **Transportation/Travel:** The receipts of transportation costs you have incurred in getting to and from a job excluding your gas receipts and parking expenses, i.e. plane and bus tickets.
- **Restaurant meals while traveling and working:** Keep all receipts.
- **Accommodations while working:** Any accommodations costs/receipts that you incur while traveling away from your residence for jobs.
- **Couriers:** Your agency will frequently use a courier on your behalf. You will not have a receipt for these expenses but you will have a record of them on your agency account printout or pay stub, which becomes your receipt. In either case, keep a copy of the amount in this envelope.
- **Union fees:** For acting jobs there will be union fees for permits, annual fees and other union expenses. Keep a record of expenses.
- **Agency-related costs:** Receipts for comps, your book, enlargements, etc.
- **Workshops & classes:** Receipts for any workshops or classes you have done to improve your skills for your career.
- **Phone costs:** Phone bills, such as part of your home phone bill, long-distance calls, cell phone and pager costs, used for your work.
- **Clothing & body care:** Receipts for clothing and shoes you purchase for work, dry cleaning of work clothing, waxing and other body and skin-care expenses incurred for work.
- **Administration:** Receipts for envelopes and stamps for notes you send to clients, faxes and gifts for agents and clients.
- **Gas & parking:** Receipts for the gas and parking expenses you have incurred going to and from work. Note that speeding tickets are not considered an expense! Also, keep receipts for the purchase or lease of your vehicle, all repairs and maintenance, insurance and interest on a loan to purchase the car specifically. You must keep track of the kilometres you drive to and from work as well as the total kilometres travelled for the year.

- **Miscellaneous:** Other expenses you have incurred while working. Keep all relevant receipts.

Once you get a receipt, then file it immediately in the proper envelope so you don't lose sight of it. You'll need to calculate your receipts every month, biannually or yearly. An easy way to make these calculations is to create a spreadsheet on your computer with the different headings in the columns and enter the amounts of the receipts in the labelled rows. At the end of the year, you can make get a total sum for each column. Here's an example:

EXPENSES SPREADSHEET

Travel	Restaurant	Accomm.	Courier	Union	Agency	Classes	Gas&Park	Phone	Clothing	Admin.	Misc
5.00	12.00	115.00	1.25	225.00	40.00	199.00	2.00	33.00	252.00	9.00	6.00
126.00	15.00	35.00	4.50	225.00	40.00	45.00	28.00	42.00	117.00	10.50	4.50
2.75	19.00	--	4.50	--	200.00	--	2.25	--	30.00	--	--
133.75	46.00	150.00	10.25	450.00	280.00	244.00	32.25	75.00	399.00	19.50	10.50

At the same time you're recording your expenses, you'll want to keep a record of your income. You need to keep track of your accounts receivable (the monies owed to you) for two reasons. First, you should be aware of the money your agency owes you. Most clients pay months after the job has been done so you need to note the details of the job so that you don't forget them. Second, you need to have a record for income tax purposes. Make a spreadsheet either on the computer, using a program like MS Excel or on some chart paper. List the date the job was performed, the client's name, your gross income - which is the total amount on your voucher, the amount you paid to the agency (20% of the gross), and your net (80% of the gross). If you're doing this work on a computer software program, you can keep a running total on the bottom. It's also beneficial to have a paid column so that you can mark when the job was paid and the date on the cheque.

If you're collecting GST, then you'll also need to keep track of the amount you'll need to submit to the government. Check with the GST office on when to remit the GST and eventually the office will send you a letter detailing this for you. Yes, you automatically get recruited as the government's GST collector - and don't lose sight of

that responsibility because GST totals can add up very quickly. Your agency will pay you the GST due on your net amount, but you'll need to keep a record of it to later submit to the government. Here's an example of how to organize your accounting for GST collection (your accountant will love you for your organized record-keeping; plus you'll save them time and your money - you would have to pay if them was doing the work for you):

WORK SPREADSHEET

Date	Client	Usage	Gross	Agency	Net	GST on Gross	GST to Agency	GST on Net	Paid Status	Special Notes
Jan.10	Chanel	Catalogue	2000.00	400.00	1600.00	140.00	28.00	112.00	Paid Mar. 14	Call Celine for a copy
Jan.29	Cdn. Living	Magazine	200.00	40.00	160.00	14.00	2.80	11.20	Paid Mar. 1	In the March Issue
		RUNNING TOTAL	2200.00	440.00	1760.00	154.00	30.80	123.20		

In this spreadsheet detailing a model's work, she will collect $140 GST on the first job. She will then pay the agency $28 GST to her agency for their services. The remaining amount, $112, is what she'll owe to the government since she has collected it on its behalf. Your agency will make these calculations automatically, but you should understand what they are doing.

MODEL'S BIO

Janine Longley

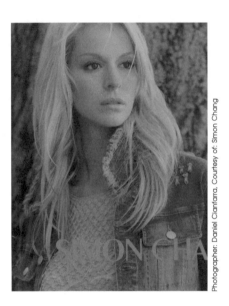
Photographer: Daniel Cianfarra, Courtesy of: Simon Chang

Photographer: Arline Malakian

How long have you been in the biz?
Six years.
Where have you worked?
I've worked in Montreal, Toronto, Barcelona, Hamburg, Madrid, Milan, Munich and Vienna.
How did you get started?
When I was sixteen, I was scouted at a mall by a New York agency but I turned it down because I didn't want to be forced to grow up too quickly and it was important to me to further my education. In my final year at the University of Western Ontario, I was scouted again and that time I decided to give it a shot.
Who are some of your clients?
In Europe I've done shows and shot for: Armani, Kritzia, Salvatore Ferragamo, Triumph, Wella and *Italian Elle*. In Canada I've done shows, catalogues and ads for: DKNY,

Escada, Arianne Lingerie, Danier Leather, Lise Watier, La Vie En Rose, Lino Catalano, Franco Mirabelli, Versace, Kenneth Cole, Ralph Lauren, Simon Chang, Sears, The Bay and Holt Renfrew.

Have you done any commercials or film & TV?

I've done commercials for Coors Light, Labatts Blue, Purolator, ProLine, Bínaca and Five Alive. I also shot in *Studio 54*, *The Skulls* and *La Femme Nikita*.

Do you have any advice for someone starting out in the business?

First, education, education, education! Don't sacrifice your education because this is a short-lived career. Second, this industry provides amazing opportunities, but it's important to always be professional and understand that there is a lot of rejection involved in modeling. It's a business and you cannot take this portion of it personally.

Do have any particular modeling memory you'd like to share?

My favourite moment in the business was when I was a judge for the Elite Look of the Year contest in the Eastern Block. In Riga, Latvia, I got to interview and talk with these contestants from such a marginalized part of the world. I was honoured to encourage them to follow their dreams, while at the same time emphasizing the importance of education.

What's the best part of modeling?

The spontaneity of my schedule.

What's the worst part of modeling?

The instability.

Financial Planning for the Next Millennium

Now that you've made some money from modeling, saving it is important. For one thing, you'll need to save your money to cover some of the recurring costs that go hand-in-hand with the job, such as new comp cards and other promotional tools. It's no different than running any other small business - you need to put some of your earnings aside to reinvest in your business and sustain a long career and other money you should put into savings. I know what you're thinking - "I don't make a lot of money, so why bother?" But, every little bit can help grow that savings pool into a big pot. This way you will be able to have your low-fat cake and eat it too!

By engaging in a savings plan you can maximize your net worth and still have some disposable income. As a young person, you'll have time on your side; that is, time for your money to earn interest and continue to grow. Here are just of few of the many savings plans available.

- **Save a little bit of your income every month.** You can set up an automatic withdrawal from your bank account. It's an easy way to save because the money is automatically withdrawn from your account and deposited into your designated investments. The advantage? With the money out of your account at the beginning of the month, you won't have to worry about spending it if it's not there.
- **Save a percentage of your income to savings.** It may seem hard or even silly to save, especially if you're working as a hobby or as an extra or part-time job, but it will be worth it. For example, you could take 10% or your earnings, or more if you can afford it, and deposit it into your savings plan where you can't touch it.
- **Contribute to RRSPs.** A registered retirement saving plan is a government program that allows you to sock away money for the future. By putting it into an account (like mutual finds) that are registered with this plan you won't have to pay income tax on the money until you withdraw it (when you're older and have limited income). Once you receive your tax assessment for the preceding year you will find out how much you are allowed to contribute for the following year. If you want to contribute before you get the assessment back, as your tax advisor for the amount she would have cal-

culated. By contributing to your RRSP you are saving yourself money on your income tax and you are helping to build your future.

Once you have a savings plan you can speak with your financial advisor about the best plan to invest your money. Ask your accountant, agent, friends and family to recommend a trustworthy financial planner. A qualified financial planner continually tracks the investment market and has knowledge on each type of investment, the risk associated with it and how a plan can mesh with your short and long-term goals. Be sure that your financial planner is associated with a well-known and reputable company and is a member of a recognized professional association, such as being a Certified Financial Planner. Ask questions about **your** money and how it will be working for you. Even if it's only a small amount you're investing, it's your money and you earned it.

Many models are very successful financially, however, the **most** successful models are the ones who have a wealth of experience and a little savings when they "retire." Along with financial consideration for the future you should always think about your life after modeling. It is not be a career that will last forever. For this reason, young models must finish, at least, high school - no matter how successful your career is becoming. Many well-recognized, successful Canadian models have also been to university or college; they often chose schools in major markets so they may work and go to school simultaneously. What do you want to do after modeling? Modeling can segue into related fields including careers as: an actor, stylist, make-up artist, hairstylist, fashion journalist, booker, personal trainer, nutritionist or magazine section-editor. Or perhaps you have an interest in another unrelated, yet fascinating field.

But, before you move on, **carpe diem!** Enjoy your modeling work and the opportunities it provides as a journey into an exciting and adventurous job. All the best and I hope to see you in some of Canada's and the world's magazines, catalogues, runways, advertisements and commercials.

APPENDICES

Model: Sarah Katherine, Photographer: Valerie Simmons

Appendices
The Ingredients • Your Resources

Appendix 1: Actor's Unions

National Office
www.actra.ca

625 Church St.
3rd floor
Toronto, ON, M4Y 2G1

☎(416) 489-1311
☎(800) 187-3516
📠(416) 489-8076

Union of B.C. Performers
www.ubcp.com

856 Homer St., #400
Vancouver, BC, V6B 2W5

☎(604) 689-0727
📠(604) 689-1145
✉info@ubcp.com

ACTRA Calgary
www.actracalgary.com

Mount Royal Place
1414-8th St. S.W., #260
Calgary, AB, T2R 1J6

☎(403) 228-3123
📠(403) 228-3299
✉calgary@actra.ca

ACTRA Edmonton
www.actraedmonton.com

10324 82nd Ave., #302
Edmonton, AB, T6E 1Z8

☎(780) 433-4090
📠(780) 433-4099
✉skilley@actra.ca

ACTRA Saskatchewan
(No site at time of printing.)

1808 Smith St., #212
Regina, SK, S4P 2N4

☎(306) 757-0885
📠(306) 359-0044
✉saskatchewan@actra.ca

ACTRA Manitoba
(No site at time of printing.)

245 McDermot Ave.
Winnipeg, MB, R3B 0S7

☎(204) 339-9750
📠(204) 947-5664
✉manitoba@actra.ca

ACTRA Toronto
www.actratoronto.com

625 Church St.
1st and 2nd floors
Toronto, ON, M4Y 2G1

☎(416) 928-2278
📠(416) 928-2852
✉info@actratoronto.com

ACTRA Ottawa
www.actraottawa.ca

Arts Court
2 Daly Ave., #170
Ottawa, ON, K1N 6E2

☎(613) 565-2168
📠(613) 565-4367
✉ottawa@actra.ca

ACTRA Montreal
www.actramontreal.ca

1450 City Councillors St., #530
Montreal, QC, H3A 2E6

☎(514) 844-3318
📠(514) 844-206
✉montreal@actra.ca

ACTRA Maritimes
(No site at time of printing.)

1660 Hollis St., #103
Halifax, NS, B3J 1V7

☎(902) 420-1404
📠(902) 422-0589
✉maritimes@actra.ca

ACTRA Newfoundland/Labrador
(No site at time of printing.)

127 Queen's Rd.
P.O. Box 575
St. John's, NF, A1C 5K8

☎(709) 722-0430
📠(709) 722-2113
✉newfoundland@actra.ca

French Language Union

UDA
www.uniondesartistes.com
Other offices can be found in Hull, Toronto and Quebec City.

3433 Stanley St.
Montreal, QC, H3A 1S2

☎(514) 288-6682
📠(514) 288-1807

Symbols:
- ☎ Telephone Number
- 📠 Fax Number
- ✉ E-mail Address

Appendix 2: Canadian Travel Info

VIA Rail

For reservations: (888) VIA-RAIL (1-888-842-7245)
Services: VIA has services to many parts of Canada but it is not economical on all routes. The busiest route for commuters is the Windsor to Quebec City corridor.
Specials: Full-time students can get discounted fares, including a great deal when purchasing six tickets at a time.
Via Preference is a consumer loyalty program where frequent travellers can get points for future free travel. For Via Preference info: (888) VIA-PREFER (1-888-842-7733) or mail@viapreference.com
Website: www.viarail.ca

Many airlines give discounts for booking online. This is a great way to save money, but then you don't have the advantages of your travel agent. A travel agent can access some rates you cannot, answer your questions and help you if there are any problems.

The airline business in Canada is changing every day. For the most current information regarding airlines, check airline information and schedules via the Internet or through your travel agent.

Air Canada (and its regional carriers including Air Jazz)

For reservations:

Calgary	(403) 265-9555
Edmonton	(708) 423-1222
Halifax	(902) 429-7111
Montreal	(514) 393-3333
Ottawa	(613) 247-5000
Quebec	(418) 692-0770
Regina	(306) 525-4711
Saskatoon	(306) 652-4181
St. John's	(709) 729-7880
Toronto	(416) 925-2311
Vancouver	(604) 688-5515
Winnipeg	(204) 943-9361
Elsewhere	(888) 247-2262

Specials: If you're 25 years old or under you can benefit from Air Canada's Youth Stand-by fare. Also, Air Canada offers "Websaver" fares, which are exclusively available on the web for travel on the upcoming weekend. With the increase in domestic airfares, it's best to wait for seat sales to purchase tickets, although you'll have to closely monitor availability.

Aeroplan is a frequent flyer program where travellers can earn points towards free flights. For Aeroplan info: (800) 361-5373 or www.areoplan.com.

Website: www.aircanada.ca

Air Canada Tango

For reservations or to change online bookings: (800) 315-1390
Services: Offers service from most cities in Canada and flies to many of the same destinations as domestic Air Canada flights. Tango has fewer flights each day than Air Canada.
Specials: When flying Tango, passengers receive Aeroplan miles but receive limited in-flight services. (Bring your own headphones, drinks and snacks.)
Website: www.flytango.com

Air Canada Zip

For reservations: (866) 4321-ZIP (1-866-432-1947)
Services: Calgary, Edmonton, Vancouver and Winnipeg.
Specials: When flying Zip, passengers receive Aeroplan miles.
Website: www.4321zip.com

CanJet

For reservations: (800) 809-7777
Services: CanJet flies to Halifax, Moncton, Montreal, Ottawa, St. John's and Toronto.
Website: www.canjet.com

jetBlue

For reservations: (800) jetBlue (1-800-538-2583)
Services: jetBlue services several cities including: Buffalo, Burlington (VT), Ft. Lauderdale, Los Angeles, New York, Rochester, Seattle and Syracuse.
Specials: jetBlue only services American cities but could be a great resource (as can many U.S. airlines) when a final destination is close to one of the airports they service (i.e., Burlington is close to Montreal, Buffalo close to Toronto and Seattle close to Vancouver).
Website: www.jetblue.com

Jetsgo

For assistance: (866) 488-5888
Services: Jetsgo travels to Charlottetown, Ft. Lauderdale, Halifax, Montreal, New York (flying to Newark, NJ), Timmins, Toronto, Vancouver and Winnipeg. Jetsgo gives limited in-flight services.
Website: www.jetsgo.net

West Jet

For reservations:
Calgary: (403) 444-2552
Toll Free: (888) WEST-JET (1-888-937-8538)
Services: West Jet flies to Abbotsford, Brandon, Calgary, Comox, Edmonton, Fort McMurray, Grande Prairie, Hamilton, Kelowna, Moncton, Ottawa, Prince George, Regina, Saskatoon, Thunder Bay, Toronto, Vancouver, Victoria and Winnipeg.
Website: www.westjet.com

Appendix 3: Glossary

ACTRA - The Alliance of Canadian Cinema, Television and Radio Artists is the Canadian actor's union.

ACTRAWORKS - The national training division of ACTRA.

Agency - A business that acts as a liaison between models and clients.

Agency Book - A book that usually dedicates a page per model to showcase an agency's models.

Agency Commission - The commission a models pays an agency on each job she performs, which is usually 20% in Canada. (The percentage that the agencies take varies greatly between countries - up to 50% in some.)

Agency Fee - The fee, usually 20% in Canada, every client pays to the agency on each job. (Not all agencies charge an agency fee to their clients; each country is different.)

Audition - A job interview that is done in front of a video camera for an acting job.

Book (AKA Portfolio) - The large book (approximately 33 cm by 26 cm) with a model's photos and comp cards used to present to clients.

Booker (AKA Agent) - An individual who works at the agency to arrange models' schedules, rates and working conditions while liaising with clients and foreign agencies.

Booking - A job whereby a client hires a model.

Booking Table - The large desk at which all the bookers in an agency sit. It has traditionally been a round table with hanging file folders or clipboards in the centre.

Breakdown - A description of talent needed for a job, which is produced by casting directors and sent to agents.

Call Back - A second casting or audition where models or actors are chosen from the first interview.

Catalogue - (1) A book that features the clothes of a designer or store. (2) A look that is usually classic and compared to the "girl next door look" (used as an adjective).

Casting - A job interview in which many models compete for a job.
Casting Director - The liaison between the director and production company and agency to find the right model or actor for a job.
Comp Card (AKA Composite, Z-Card or Card) - A model's business card that is approximately 13 cm by 20 cm that features her photos, measurements and agency's name.
Contact Sheet - A sheet of photographic paper that hold many small (thumbnail) photos taken during a shoot from which enlargements are chosen.
Client- The person who hires the model. This could be an ad agency, a producer, a photographer or a business with a good or service to promote.
Creative - A free test where all those involved are looking to get great, new photos for their own books.
Direct Booking - A booking where the model is brought in from another city at the expense of the client.
Editorial - (1) A fashion spread in a magazine that is produced by the magazine. (2) A look that is very trendy and is being featured in magazines (used as an adjective).
Fitting - A job where a model either tries on clothes to ensure they fit for a future booking or tries on a designer's samples to help determine the size and proportions of the clothing line.
Glossy - Another name for an actor's 8"x10" headshot.
Go-See - An interview whereby a model "goes" and "sees" a client.
GST Number - The Good and Services Tax is a 7% federal tax. The GST number is the business number which a models uses in order to collect and submit GST.
Head sheet - A poster with small photos of the agency's models on their roster.
Headshot - An 8"x10" photo an actor's uses to secure auditions and work.
HST - The Harmonized Sales Tax is a combined tax that includes provincial tax and federal GST. The 15% HST is found in Newfoundland, Nova Scotia and New Brunswick.

Lifestyle - The style or feeling of a shot that focuses on the mood of the scene and promotes a certain lifestyle; generally the clothes are secondary to a product that is being sold.

Models - See explanations of different types of models and modeling in the "Types of Models" section on pages 17 thru 23.

Model Bag (AKA Model's Bag) - The bag a model carries to bookings (and castings) that contains a portfolio and other essentials.

Mother Agent/Agency - The agency the model has been represented by the longest, often her first agency. This agency acts as a manager to develop the model's career and represent her to other markets.

Open Call - The few hours each week when agencies invite potential models to walk in and meet a booker and be interviewed by the agency.

Release - A legal form giving the clients or studio permission to reproduce an image in any way they wish.

Second Book - A colour copy of your portfolio that the agency sends out.

Slate - The first part of an audition where a model or actor greets the camera, says her name and the name of the agency, and often shows her profile and hands.

Stylist - The person who is responsible at a job for the clothing, its care and its appearance.

Talent - The actors on a film, TV or commercial set.

Tear sheets - Printed pages from magazines.

Test - A photo shoot that is not a job but is designed for models to get photos to use in their books.

UBCP - The Union of B.C. Performers is the name of ACTRA in British Columbia.

UDA - The Union des Artistes is the union in Canada for French language projects.

Voucher - A record of each job that shows the details of the job containing the client's and model's signatures.

Appendix 4: Other Resource Books

Hair and Make-up Books

Aucoin, Kevin. *Making Faces.* New York: Little, Brown and Company, 1997.

Brown, Bobbi. *Bobbi Brown Teenage Beauty: Everything You Need to Look Pretty, Natural, Sexy and Awesome.* New York: Harper Collins, 2001.

Gordon, Marsha, M.D. and Alice E. Fugate. *The Complete Idiot's Guide to Beautiful Skin.* New York: Alpha Books, 1999.

Acting Books

Bryan, Mark, Julia Cameron, and Catherine Allen. *The Artist's Way at Work: Right the Dragon, Twelve Weeks to Creative Freedom.* New York: William Morrow and Company, 1998.

Hurtes, Hettie Lynn. *The Back Stage Guide to Casting Directors. 2nd Edition.* New York: Back Stage Books, 1998.

Schurtleff, Michael. *Audition.* New York: Bantam Books, 1978.

Bodycare Books

Bardey, Catherine. *Secrets of the Spas: Pamper and Vitalize Yourself at Home.* New York: Black Dog & Leventhal Publishers, 1999.

D'Adamo, Peter, J. *Eat Right For Your Type: The Individualized Diet Solution to Staying Healthy, Living Longer & Achieving Your Ideal Weight.* New York: G.P. Putnam's Sons, 1996.

Siler, Brooke. *The Pilates Body: The Ultimate At-Home Guide To Strengthening, Lengthening, and Toning Your Body - Without Machines.* New York: Broadway Books, 2000.

Self-Help and Career Books

Branden, Nathaniel. *The Six Pillars of Self-Esteem.* New York: Bantam Books, 1994.

Carlson, Richard. *Don't Sweat the Small Stuff: and It's All Small Stuff.* New York: Hyperion, 1997.

Harold, Fiona. *Be Your Own Life Coach: How to Take Control of Your Life and Achieve Your Wildest Dreams.* London: Hodder, 2003.

James, Gregory (Publisher). *Model and Talent 2003: International Directory of Model and Talent Agencies and Schools.* New York: Peter Glenn Publications, 2002.

Katselas, Milton. *Dreams Into Action: Getting What You Want!* Sydney: Harper Collins, 1997.

McGraw, Phillip C. Life Strategies: *Doing What Works, Doing What Matters.* New York: Hyperion, 1999.

Seitz, Victoria A. *Your Executive Image: The Art of Self-packaging for Men and Women.* Massachusetts: Bob Adams, Inc., 1992.

Financial Books

Carlson, Richard. *Don't Sweat the Small Stuff About Money: Spiritual and Practical Ways to Create Abundance and More Fun in Your Life.* New York: Hyperion, 1997.

Chilton, David. *The Wealthy Barber.* Gold Edition. Toronto: Stoddart, 2001.

Lynch, Peter and John Rothchild. *Learn to Earn: A Beginner's Guide to the Basics of Investing and Business.* New York: Fireside, 1995.

Online References

As with any website, the content is always being edited and one must question its source to determine its validity.

www.canadianactor.com
This website is an industry resource for the support of Canadian actors and other entertainment industry professionals including models.

www.ccra.gc.ca
This government website features the Guide for Canadian Small Businesses, including income tax and GST/HST information.

www.modelwatcher.com
This basic website is a newsletter about male modeling and fashion with lots of contemporary photos.

www.plusmodels.com
This website is designed as an in-depth resource for plus-size models.

Index

acting 21, 48, 49, 53, 86-90, 100, 114, 117
actor 48, 86, 87, 91, 107, 109, 114-117, 119
ACTRA (see also union) 87-89, 109, 114
ACTRAWORKS 89, 114
ads/advertisements 11, 17, 21, 22, 28, 42, 56, 60, 67, 72, 73, 79, 89, 104, 107
AFTRA 87
agency 14, 15, 21, 23-30, 32-35, 39-46, 48, 57, 62, 64, 71-74, 78, 79, 81-85, 89, 91, 92, 94, 97-102, 104, 114, 116, 118
agency book 44, 46, 114
agent 12, 15, 25-27, 30, 33-35, 40, 49, 53, 60, 68, 71-74, 79-81, 86, 87, 89, 90, 107, 114
Air Canada 111, 112
Asia (see also Japan) 33, 60, 74, 81, 94
athletic 22, 76
Andreesen, Rainer 23
audition 68, 89-91, 114, 116, 117
babies (see also child, children and kids) 21, 43, 76, 92
Bardai, Zohar 57, 58
beauty 51, 59
beauty model 17, 22
Bell, Alecia 92
Be Your Own Life Coach 23, 118
body care 58, 100
body hair 59, 62
book (see also portfolio) 11, 12, 14, 15, 24, 27, 29, 37, 40, 43-45, 49, 57, 69, 71, 72, 83, 92, 100, 114, 117
booker 27-29, 32, 33, 62, 72, 92, 93, 107, 114, 116
booking 32, 43, 44, 49, 62, 72, 74, 77, 111, 114, 115
booking table 32, 114
bookkeeping 97, 99, 100
Branden, Nathaniel 63, 118
call back 25, 26, 91, 114
Canada (see also Montreal, Toronto and Vancouver) 12, 20, 29, 36, 48, 60, 69, 74, 79, 81, 91, 92, 93, 95, 97-99, 104, 107, 110-112, 114, 116, 125
Canadian 12, 13, 21, 23, 29, 30, 33, 42, 60, 74, 77, 78, 86-88, 91-93, 95, 97-99, 107, 111, 114, 119, 125
CanJet 112
catalogue 17-20, 23, 37, 39, 41, 43, 44, 48, 66, 69, 71, 73, 76, 80, 85, 92, 93, 102, 114

catalogue model 17-19, 71, 73, 74
casting 39, 41, 42, 53, 59, 62, 72, 73, 86, 89-91, 94, 114, 115, 117
casting director 89-91, 115
child 14, 15, 21, 28, 29, 89
children (see also babies, child and kids) 21, 44
client 27, 29, 30, 34, 39, 41, 43, 44, 54, 66, 69, 71-74, 77-80, 89, 91, 97, 101, 114-116
Clin d'Oeil 23, 60, 68, 92, 125
clothing (see also outfit) 22, 23, 28, 39-42, 48, 73, 74, 86, 90, 100, 101, 116
commercial 23, 41, 48, 60, 71, 87-91, 93, 95, 116
commercials 22, 35, 60, 67, 81, 86, 87, 93, 95, 105, 107, 125
commission, agency 34, 35, 91, 97, 101, 102, 114
comp card 26, 39, 40, 49, 56, 59, 69, 86, 89, 106, 114, 115
Conrad 48, 49
contact sheet 71, 115
convention, modeling 26, 27
Coventry, Alex 36, 37
creatives (see also test) 71, 115
Croft, Rhonda 29, 92
Danza, Tony 61
dental care (see also teeth) 54, 55
direct bookings 74, 92, 115
drugs 15, 59, 61
editorial 19, 20, 23, 72, 75, 92, 93, 115
editorial model 19, 23
Elite Models 92, 105
Elle 46, 60, 81, 92, 104
Europe 12, 36, 56, 60, 68, 69, 74, 78, 81, 83-85, 92, 93, 104, 125
eyes 51, 63, 65, 75
eyebrows 53, 54
fashion show (see also show) 11, 39, 68, 77, 85, 92, 93
fee 28, 29, 34, 79, 88, 97, 98, 114
fee, agency 97, 114
film 62, 77
films (feature) 22, 37, 48, 49, 67, 86, 87, 92, 93, 95, 105, 116, 125
financial planner/planning 97, 106, 107, 119
fitness model/modeling 22
fitting 73, 74, 115
Flanagan, Dr. Lloyd 8, 56
Giovanni Models 93
glasses 44, 53, 69, 86
glossy (see also headshot) 89, 115

go-see 39, 41, 42, 53, 57, 86, 115
GST (goods and services tax) (see also tax) 98, 99, 101, 102, 115, 119
hair 23, 25, 27, 40, 41, 43, 44, 49, 51, 52, 57-59, 62, 66, 67, 69, 71, 72, 82, 86, 90, 117
hair removal 59, 62
hairstylist 57, 58, 74, 107
hands 22, 56, 76, 91, 116
Harold, Fiona 23, 118
Hawley, Richard 93
head sheet 44, 46, 115,
headshot (see also glossy) 86, 115
HST (harmonized sales tax) (see also tax) 98, 99, 115, 119
income tax (see also tax) 97-99, 101, 106, 107, 119
insurance (dental and health) 54, 75, 89
Japan (see also Asia) 21, 74, 82, 93, 94, 125
jetBlue 113
Jetsgo 113
Kamera Kids 20, 29
kids (see also babies, child and children) 21, 29, 40, 44, 92
Laisné, Isabelle 93
Lavoie, Sandra 30
Longley, Janine 104, 105
lifestyle 57-59, 75, 95, 115
lifestyle shot 75 115
legs 22, 39, 62
make-up 23-25, 27, 39, 41, 42, 51, 52, 64-67, 71, 72, 74, 86, 90, 107, 117
make-up artist 52, 65, 66, 67, 70-72, 74, 107
male model 20, 23, 44, 119
McNiven, Cristy 84, 85
Model's Bio 13, 36, 37, 48, 49, 60, 61, 68, 69, 84, 85, 94, 95, 104, 105
model tips (see 'quick model tip')
models, types of 17-23
model bag 42-44, 116
Montreal 23, 32, 34, 36, 48, 57, 60, 68, 69, 76-78, 86, 92-94, 104, 109-113, 125
mother agency/agent 34, 35, 81, 85, 116
nails 51, 56
Nadeau, Chantale 60, 61
open call 25-27, 32, 88, 116
outfit (see also clothing) 41
"Quick Model Tip" 13, 21, 29, 39-43, 51-55, 57-59, 62, 66, 67, 81, 89, 91, 99
rates 27, 74, 87, 92, 93, 111, 114
release 79

Ross, Manoushka 32, 33, 93
runway 18-20, 22, 24, 25, 77, 84, 92, 93
SAG 87
school, modeling (and classes) 15, 24, 25, 67, 77, 100
second book 45, 46, 116
self-esteem 14, 30, 51, 52, 63, 64, 95, 118
stylist 44, 43, 71, 72, 107, 116
show (see also fashion show) 11, 18, 25, 36, 38, 68, 73, 74, 77, 78, 85, 92, 93
Sim, Lisa 52, 65, 67
skin 17, 27, 44, 49, 51-55, 59, 65, 86, 100, 125
slate 91, 116
snapshots 27
Sophie 68, 69, 77
SPECS Models 32, 93
spreadsheet 101, 102
Sutherland, Ann 24
Sutherland Models 24
tax (see also income tax, GST and HST) 54, 97-99, 101, 106, 107, 115, 119
Tea, Kalyane 94, 95
teeth (see also dental care) 17, 51, 54-56, 59, 67, 75
test 29, 71, 72, 116
testing 70
The Six Pillars of Self-Esteem 63, 64, 118
Toronto 21, 23, 24, 36, 37, 45, 48, 60, 68, 69, 71, 76, 77, 86, 88, 90, 92, 94, 104, 108, 110, 111-113, 119
travel 12, 17, 26, 33, 37, 40, 60, 61, 69, 74, 81, 82, 85, 92, 94, 95, 100, 101, 111-113
travel agent 111
TV 37, 48, 60, 77, 86-88, 93, 95, 105, 116
UBCP (see also union) 87, 109, 116
UDA (see also union) 87, 110, 116
union (see also ACTRA, UBCP and UDA) 21, 87-89, 91, 100, 109, 114
union expenses 100
United States (U.S.) 36, 48, 60, 81, 84, 92-94, 113
Vancouver 66, 84, 86, 93, 109, 111-113, 125
Via Rail 111
voucher 43, 44, 78, 79, 97, 101, 116
West Jet 113
z-card (see comp card) 40, 115

ABOUT THE AUTHOR

About the Author

Heather's 14-year career is an example of the rewards of hard work and professionalism. Growing up in Waterloo, Ontario, Heather would commute to Toronto for auditions and jobs during high school. She spent two summers in Paris, where she did her first magazine cover in 1992. After high school and during university she worked abroad in Athens, Barcelona, Hamburg, Milan and Osaka. In Europe, she shot for hundreds of magazines and catalogues with some of the best photographers in the business. She has been in dozens of commercials, television shows and films in Canada, the United States and around the world. The prestigious fashion magazine, *Clin d'Oeil* featured Heather in one of its articles profiling ten of Canada's top models. Also, she is proud to be the spokes model for Bioré skin-care products.

Heather has enjoyed an impressive career and, with the support of the Canadian modeling industry, is now giving back to business. She has written the essential handbook for models so that she can help empower the next generation of models to be the most respected and professional models yet!

She spends her time touring the country giving seminars to aspiring and new models, reading, playing hockey, practising yoga and swimming. Heather calls home any number of cities, but these days it's Montreal, Vancouver and Waterloo. Please contact her through the publishing company or at heather.young@shaw.ca.

Give the Gift of A Modeling Career to Someone Special!

Help them learn the ins and outs of this exciting business.

CHECK YOUR FAVOURITE BOOK STORE OR ORDER HERE

YES! I want ___ copies of *More Than A Pretty Face: The Essential Handbook for Canadian Models* at $30.00 each, plus $4 shipping per book. (Please add $2.10 GST per book. ~~British Columbia residents please also add $2.25 PST per book.~~)

My cheque or money order made payable to Feather Books is enclosed.

Name _____
Address _____
City, Province, PC _____
Phone _____
E-mail _____

<u>Please return to:</u>
Feather Books
14878 - 59th Avenue
Surrey, BC, V3S 3W8

ORDER NOW ON OUR SECURE WEBSITE
WWW.FEATHERBOOKS.CA

Please keep in mind that a discount is available on large orders.